YORKSHIRE MADE ME

YORKSHIRE

MADE ME

JENNIFER ROBERTSON & LYNNE FLETCHER

NICOLA ADAMS MICHAEL P.
BETTY BOOTHROYD HANNAH
LIZ GREEN JENNI MURRAY
BRIAN ROBINSON HELEN
WILF LUNN MICHAEL PALIN
FIONA WOOD CLARE TEAL
DICKIE BIRD GEOFF BOYCOTT
PATRICK STEWART LESLEY
KIKI DEE SIMON HIRST DA
JOANN FLETCHER BERNARD
DUNCAN PRESTON SALLY WA

ARKINSON JOE WILLOUGHBY

COCKROFT MAUREEN LIPMAN

JIM CARTER JOHN GODBER

HARMAN EMMA INGILBY

BARRIE RUTTER MEL DKYE

KAY MELLOR HAYLEY TAYLOR

JUDI DENCH BRIAN BLESSED

GARRETT WILLIAM HAGUE

ID BLUNKETT JOANNE HARRIS

INGHAM LUKE ROBINSON

INWRIGHT DAVID HOCKNEY

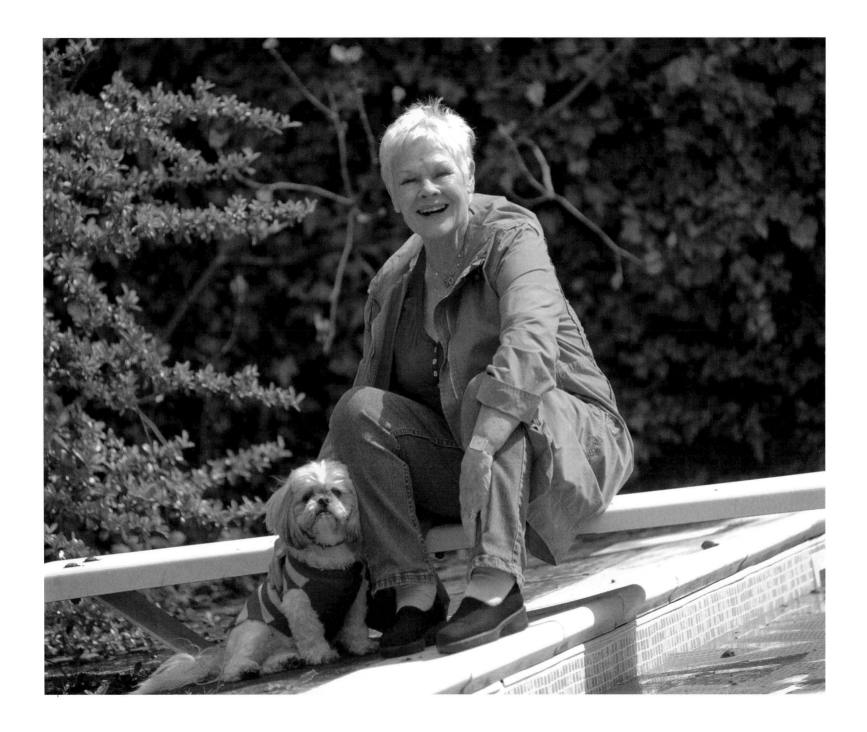

"As diverse as the county of Yorkshire is, so too are the people who come from there. I am unbelievably proud to have been born in York. The 'Yorkshire Made Me' project is self-explanatory, and I am proud to be part of that too"

Dame Judi Dench

Dedications

To Val, Norman, Ella, David and
especially to Joanne Fernside who has
been with us every step of the way.

Special thanks

Up hill and down dale … this magical three-year journey,
photographing just some of our county's amazing people for
this collection, would not have been possible without the
generosity and time given by all those featured in the book.
Thank you for believing and trusting in our abilities.

Endless thanks goes to Joanne Harris, who kept us focused
on how wonderful Yorkshire is and kindly wrote the foreword.
And also to Joanne's PA, Anne Riley, who helped us along
the way and gave us lots of giggles!

Thank you also to Liz Green and Kimberley Metcalfe at the BBC
for inspiration, encouragement and friendship throughout.
They both kept us going when we were flagging! Sally Wainwright,
Lesley Garrett, Kiki Dee and Mel Dyke: thanks for championing our
work. To Joe Willoughby, who made us believe anything in life is
possible! Thank you Duncan Preston for being the first person to
agree to sit for our collection.

And last but not least, to Judi Dench, for her
kindness, on-going support, coffee and fig rolls.

Foreword

The first thing you realise about coming from Yorkshire is how little some outsiders know or care about England's largest county. Coming from Barnsley is even more difficult. As I achieved success in my field I almost came to dread telling southerners where I was from, for fear of the traditional response: "Ooooh, Ba-aaaaaaaarnsley!" they would chorus, like the rowdy back row at a Christmas pantomime, after which they would express surprise that I didn't have an accent (no surprise there; my first language was French).

Now I live in Huddersfield the chorus has changed to: "Ooooh, 'Uddersfield!" often followed by polite disbelief when I say how much I like living there. After all, who wouldn't prefer to live in London or LA, where there's a Starbucks every ten yards and no-one looks you in the eye? Even now, lots of people still assume that I live in France, or in London, or somewhere more urban and closer to the centre of what the press thinks of as 'the literary world' – that is, somewhere between Bloomsbury and South Kensington.

The fact is I like it here. And when my southern friends come to stay, they are often astonished by what they find. Yorkshire is amazingly diverse, rich in heritage and culture. My neighbours, both historical and current, include among many: the Brontës; David Hockney; Ted Hughes; Bruce Chatwin; W. H. Auden; Barbara Hepworth; and Henry Moore. I am within half an hour of some of the finest theatres, museums and art galleries in the country: the Crucible Theatre, the West Yorkshire Playhouse, the Yorkshire Sculpture Park and the Royal Armouries being only a few of these. We have more

Michelin-starred restaurants than anywhere outside London (and we know how to make proper fish and chips, a skill that the South still has to acquire). Our heritage is second to none: we have York Minster, the largest Gothic cathedral in northern Europe; Mother Shipton's Cave, the oldest visitor attraction in the world; plus a continuing sporting tradition, including the hosting of the Grand Départ of the Tour de France in 2014. And if that wasn't enough, we have some of the most stunning countryside – moorland, mountains, coastline – in the whole of the British Isles.

But those are only the obvious reasons for me to appreciate Yorkshire. The real, visceral, emotive reasons run far deeper than those things. So what if I can take my morning walk along the ridge of Wuthering Heights, or shop at Harvey Nichols, or see a West End touring show for half the price of a West End ticket? So what if I can run into Patrick Stewart at my local supermarket? Or find Stone Age arrowheads while I'm walking on the moors, and Viking remains in my back garden? Yorkshire is more than architecture, or countryside, or the arts. There's something about this county that can't be described in terms of what or where.

Perhaps it's the spirit of the place; its magical, elusive charm, its wealth of stories, its folklore. Or perhaps it's the people – friendly, artistic, loyal, eccentric, slightly combative, perhaps, but direct and never at a loss for words.

Here are a few of those people. I hope you find them as inspirational as I do.

Joanne Harris, January 2014

Yorkshire Made Me

Yorkshire has produced some exceptional people whose creativity, talent, sporting success and ability to shape modern Britain is outstanding.

Award-winning Yorkshire photographers, Jennifer Robertson and Lynne Fletcher, collectively known as Kyte Photography, have spent over three years creating this unique collection of portraits. Taken especially for this book, these pictures celebrate the inspirational Yorkshire men and women who are exceptional in their chosen field.

From the giants of entertainment, to writers, politicians, academics, journalists and sporting heroes bringing home Olympic Gold to twenty-first century Britain, these photographs tell a story of the people whose success and achievements makes them proud to be Yorkshire 'born and bred'.

Yorkshire Made Me is a true celebration of the great county; 'God's own county'. The book honours its remarkable people and its amazing beauty; from the rolling hills of the Yorkshire Dales, to the ancient cobbled streets steeped in history and charm. What comes across most powerfully is that no matter how far Yorkshire men and women go, in distance or stardom, they are forever shaped by their place of birth and are intensely proud to belong.

In 2010, Kyte won a Master Photography Award; a consumer award for their portraiture. They went on to retain that title in 2011.

Jennifer Robertson, born 1964, is an award-winning portrait photographer from Sheffield. She is a Master Photographer (LMPA), and a member of the Royal Photographic Society (LRPS).

Formally a leading national press photographer, her front page world exclusives include the arrest of serial killer Dr Harold Shipman and images of the Manchester IRA bombing. Her photographs of celebrities and royals have appeared in newspapers and international magazines from the *Mail on Sunday*, and *Hello*, to *Cosmopolitan, FHM* and *Paris Match.*

Jennifer started her career as a junior photographer on the *Barnsley Chronicle*. She quickly worked her way up the regional newspaper scene to head the picture desk of the North's leading press agency, Cavendish Press in Manchester. She retained this position for over a decade, resulting in her becoming one of the country's leading press photographers.

Lynne Fletcher, born 1965, is a former creative art director for Weber Shandwick, one of the world's leading global public relations firms. She has worked on many successful campaigns for Manchester United FC, Tatton Park, the Royal Horticultural Society, Coca Cola, and Shell UK. Lynne specialises in studio and location lighting, and sources photographic locations for magazine features and celebrity photo-shoots.

A Lancastrian by birth, Lynne has long since been adopted by Yorkshire. She tries not to mention the fact that she crossed the Pennines!

Jennifer and Lynne opened their first studio in 2001, nestled in Yorkshire's beautiful Calder Valley. They specialise in contemporary lifestyle portraiture, of people from all walks of life. Their photographs range from everyday folk, through to celebrities, and TV production stills for award-winning dramas.

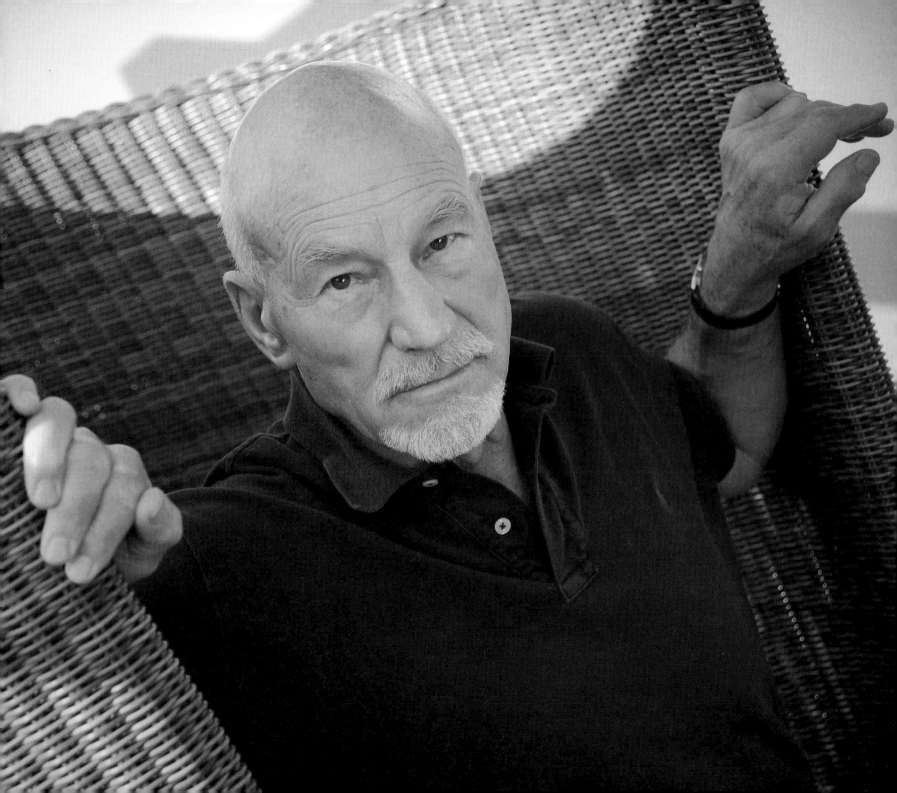

You can always tell a
Yorkshireman … but you
can't tell him much!

Patrick Stewart

24 JULY 2012 – EMLEY MOOR, HUDDERSFIELD, WEST YORKSHIRE

Sir Patrick Stewart; OBE – born 13 July 1940, Mirfield, West Yorkshire – is an actor with a distinguished career in film, theatre and television spanning over fifty years. He is probably most widely known for his film roles as Captain Jean-Luc Picard in a string of successful *Star Trek* films and in the *X-Men* film series.

He became a member of the Royal Shakespeare Company in 1966, was an Associate Artist of the company in 1968 and stayed with them until 1982, appearing in more than sixty productions.

In 2004, Patrick was appointed Chancellor of the University of Huddersfield and subsequently a Professor of Performing Arts in 2008. He is President of Huddersfield Town Academy, the local football club's project for identifying and developing young talent, and is a lifelong supporter of the club.

Patrick was awarded Knight Bachelor of the Order of the British Empire in the 2010 Queen's New Year's Honours List for his accomplishments in theatre, film and television.

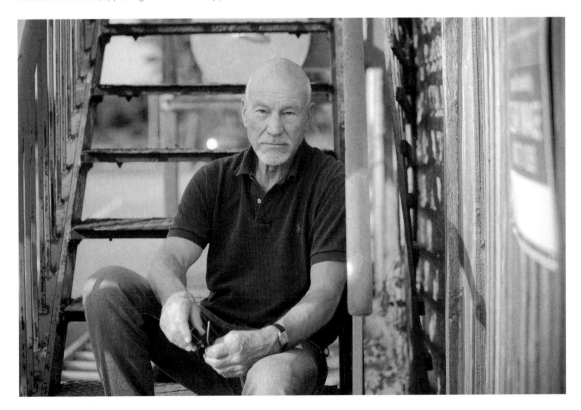

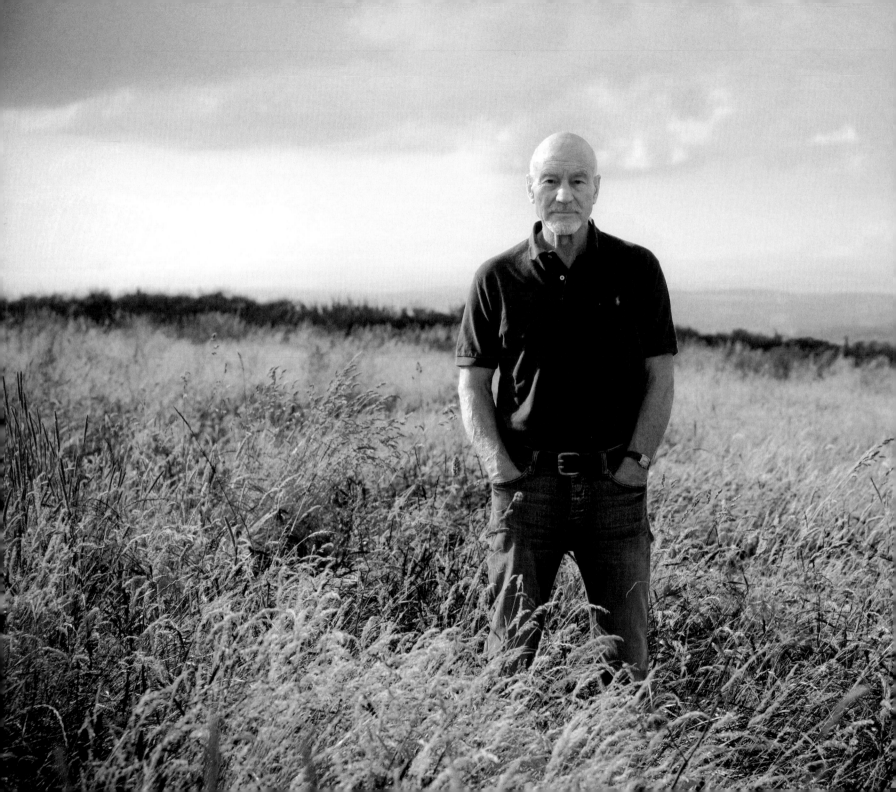

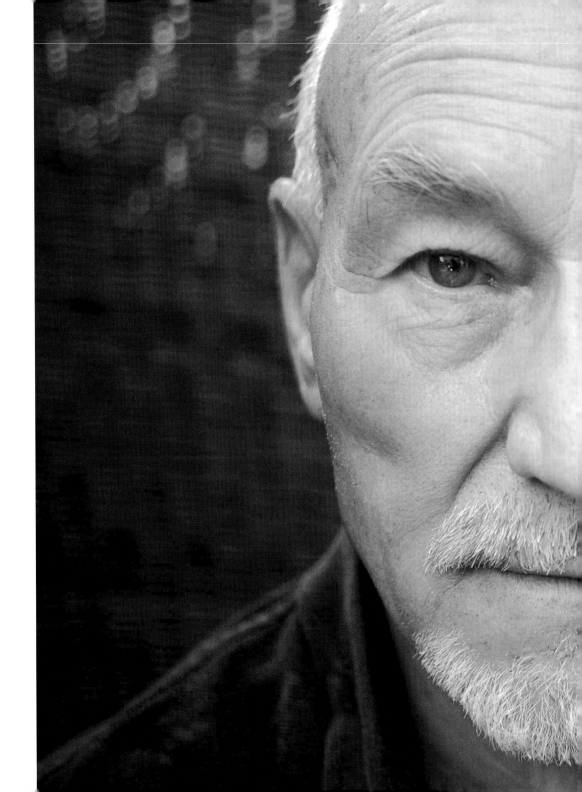

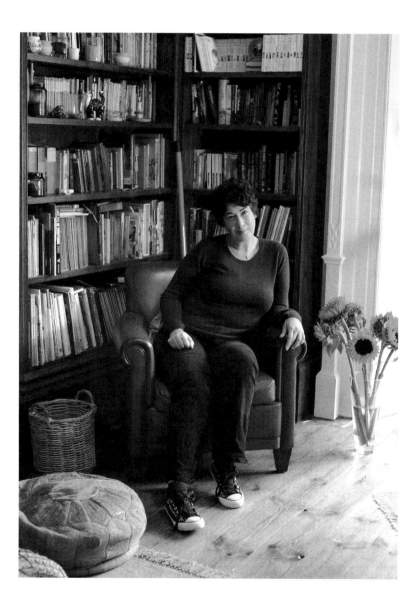

Joanne Harris

20 SEPTEMBER 2011 – JOANNE'S HOME, ALMONDBURY, WEST YORKSHIRE

Joanne Harris, MBE – born 3 July 1964, Barnsley, South Yorkshire – is an award-winning author. She has written fifteen novels, but it was the success of the adaptation of her novel *Chocolat* staring Johnny Depp and Juliette Binoche that brought her worldwide recognition.

Her books are now published in over fifty countries and have won a number of British and international awards. In 2004, Joanne was one of the judges of the Whitbread Prize and in 2005 she was a judge of the Orange Prize. In June 2013, Joanne was awarded an MBE in the Queen's Birthday Honours List.

Her favourite colour is arterial red, she plays bass guitar in a band first formed when she was sixteen, she really, really hates wasps and still lives about fifteen miles from the place where she was born.

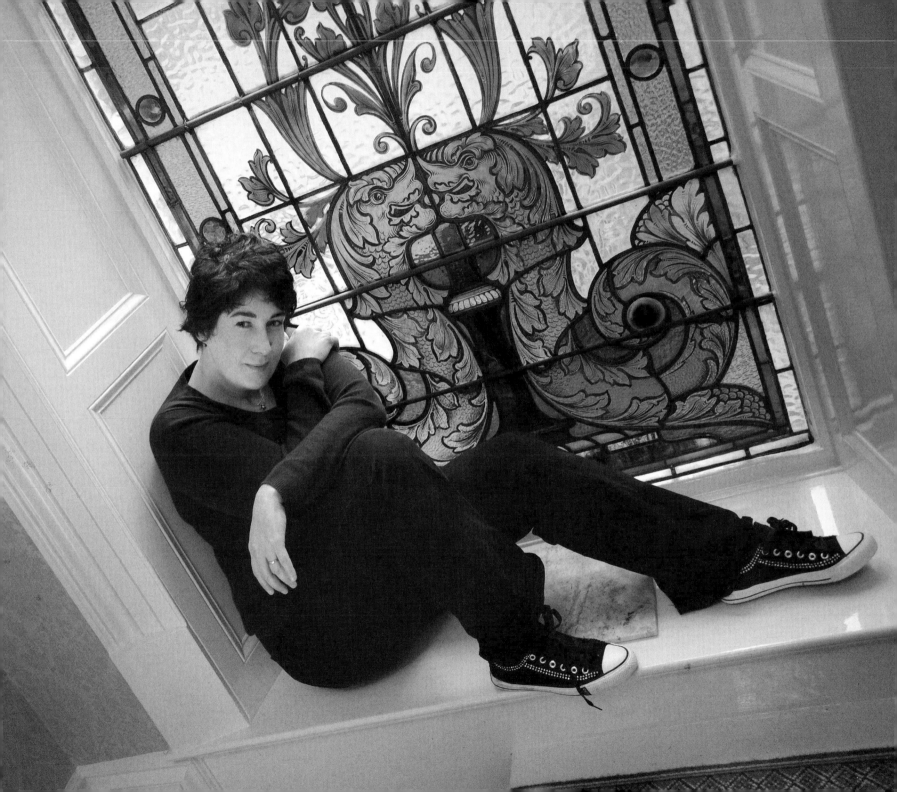

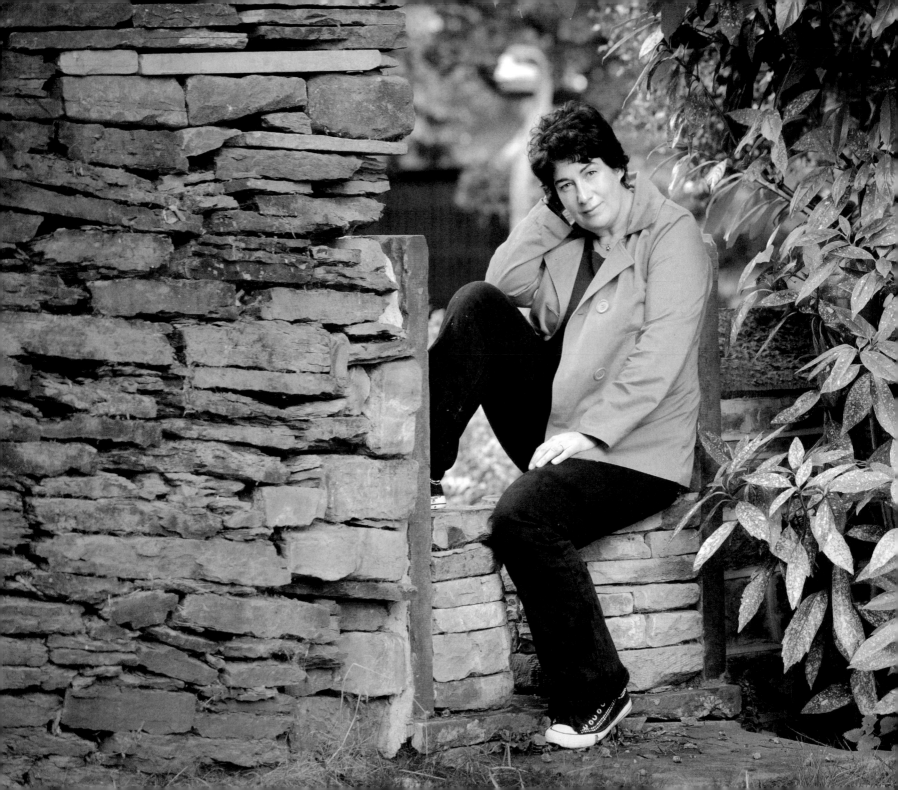

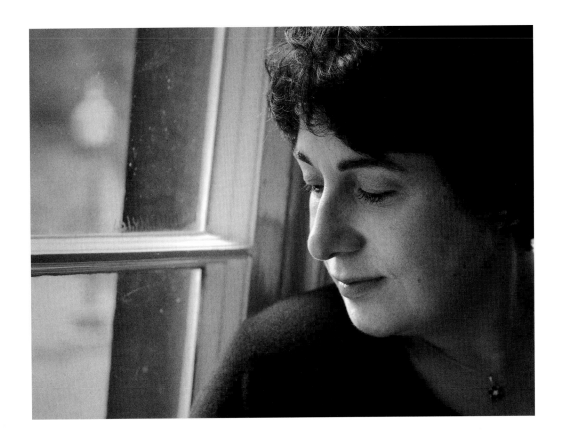

Yorkshire is my home.
For a nomad like me that means
everything. I love the people and
its violent, beautiful landscape

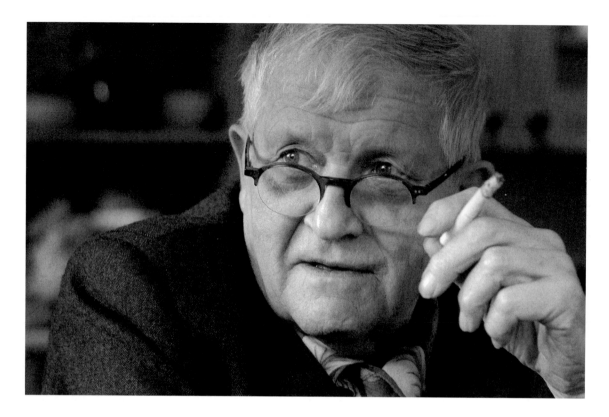

David Hockney

David Hockney, OM, CH – born 9 July 1937, Bradford, West Yorkshire – is one of the most popular and influential British artists of the twentieth century.

He was educated at Bradford Grammar School, Bradford School of Art and the Royal College of Art, London.

He moved to Los Angeles in the 1960s where he painted his famous swimming pool scenes. In the 1970s and early '80s, he began working in photography, creating photocollages he called 'joiners'.

In June 2007, David's largest painting, *Bigger Trees Near Warter*, was hung in the Royal Academy's largest gallery. The work on a monumental scale features two copses painted on 50 individual canvases and takes inspiration from a site at Warter in the East Riding of Yorkshire. In 2012 the Royal Academy presented the exhibition *A Bigger Picture*, a collection of over 150 works dedicated to landscapes, especially trees, inspired by David's native Yorkshire.

David continues to create and exhibit art. There is a permanent collection of David's work displayed at Salts Mill in his hometown of Bradford.

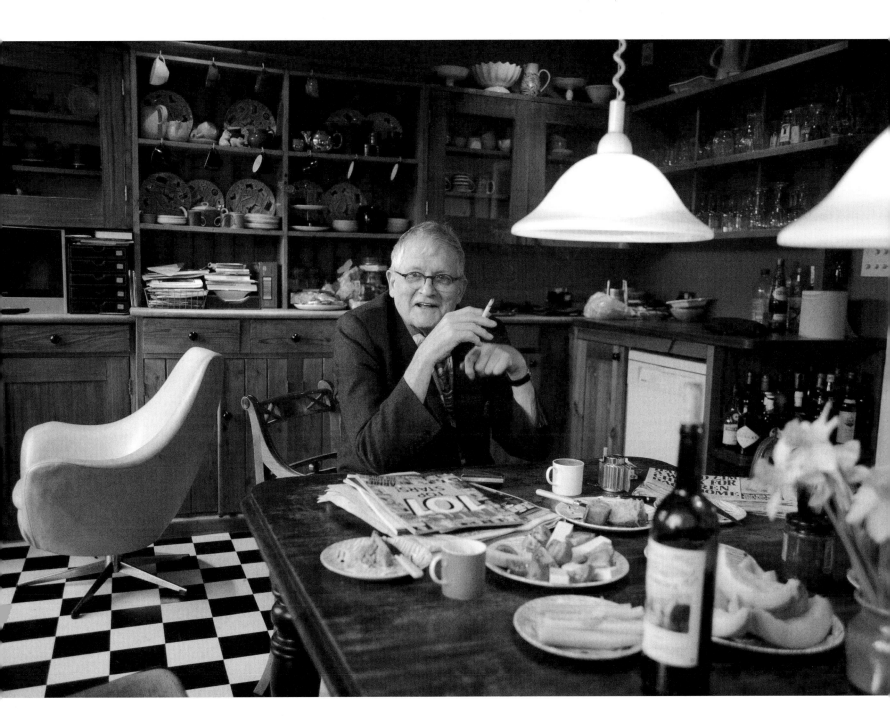

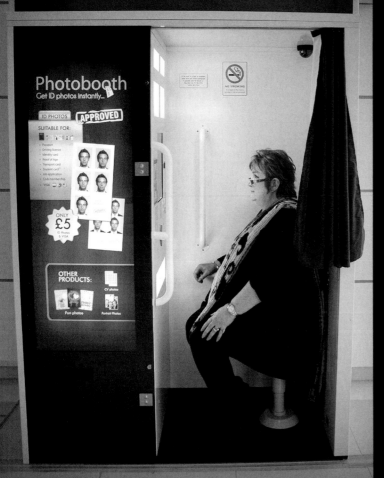
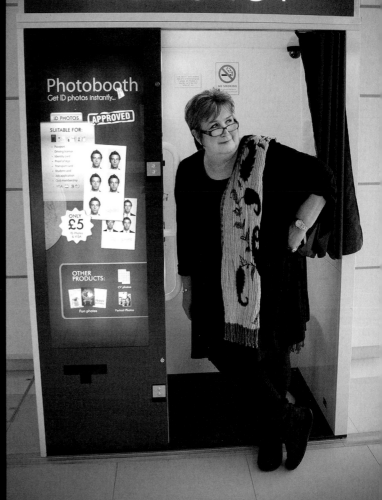

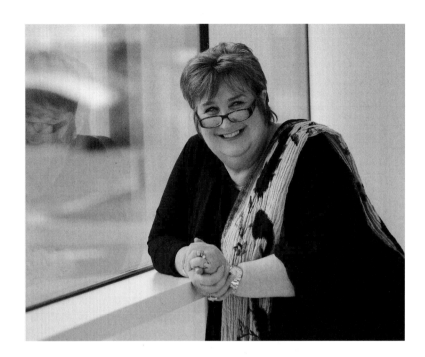

Jenni Murray

9 MARCH 2012 – MEDIA CITY, SALFORD, GREATER MANCHESTER

Dame Jenni Murray, OBE, DBE – born 12 May 1950, Barnsley, South Yorkshire – is a journalist, broadcaster and author. She is best known as a presenter on BBC Radio 4's *Woman's Hour*, which she joined in 1987.

She was awarded an OBE for services to broadcasting in 1999 and Dame Commander of the Order of the British Empire (DBE) in the 2011 Birthday Honours.

Jenni is also a patron of the Family Planning Association and patron of Breast Cancer Campaign, President Fawcett and Non-Executive Director of the Christie Charity. She is also a distinguished supporter of the British Humanist Association.

If a stranger to Yorkshire
only had time to visit
one place, I would have
to recommend Barnsley
– of course!

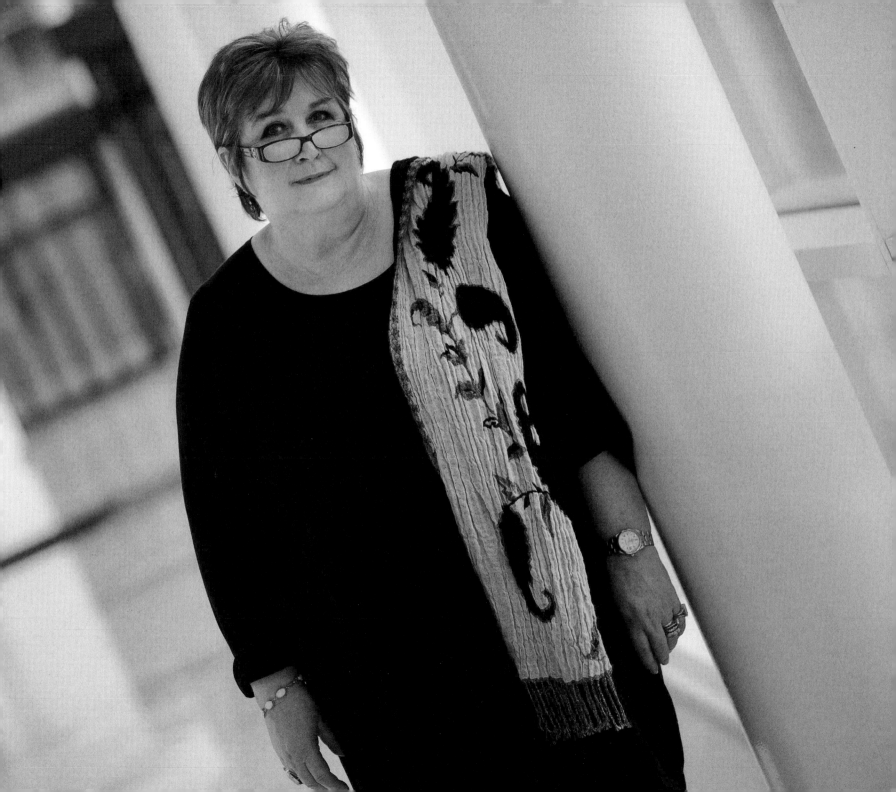

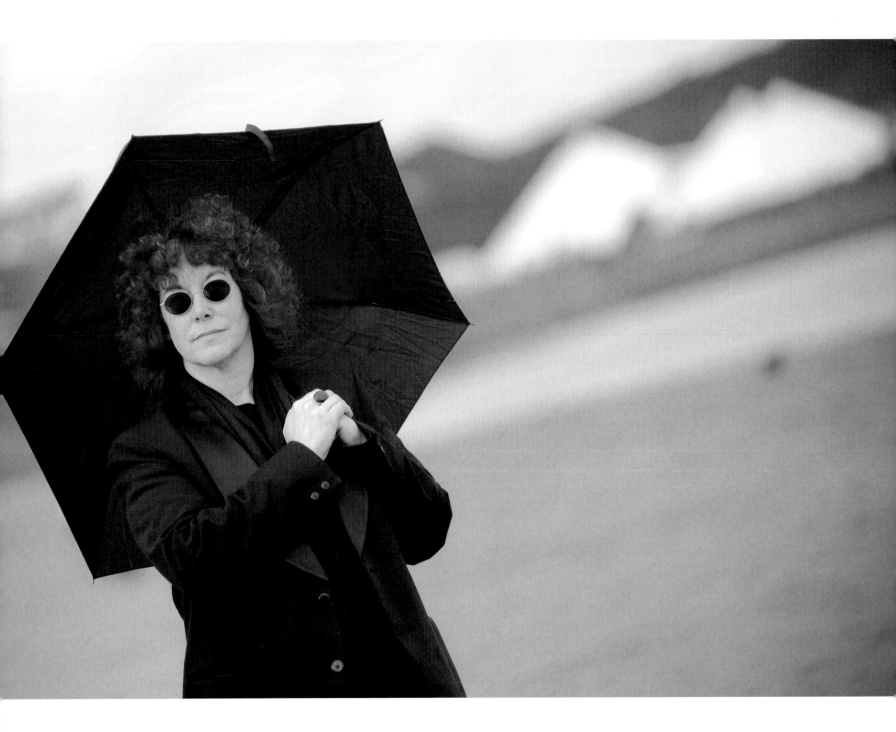

Joann Fletcher

30 OCTOBER 2011 – SCARBOROUGH, NORTH YORKSHIRE

Professor Joann Fletcher – born 30 August 1966, Barnsley, South Yorkshire – is Honorary Visiting Professor in the Department of Archaeology at the University of York, and Consultant Egyptologist for Harrogate Museums and Arts.

She has undertaken excavation work in Egypt, Yemen and the UK and has examined mummies both on site and in collections around the world. In 2003, Professor Fletcher and her team initiated an eight-year project that overturned the understanding of Egyptian mummification. Filmed and shown as the Channel 4 documentary, *Mummifying Alan – Egypt's Last Secret*, October 2011 – it won the Royal Television Society Award in the Science category, the BAFTA for 'Specialist Factual' and the Association for International Broadcasting Award for 'best science programme'.

She has written eight books to date, and in 2013 she wrote and presented BBC2's top-rated *Life & Death in the Valley of the Kings*.

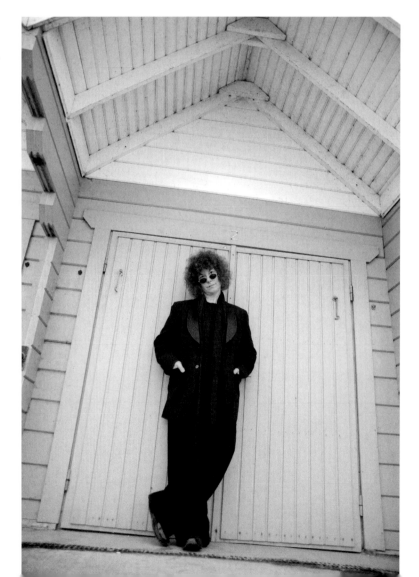

My favourite thing about Yorkshire? Tricky one this, everything about Yorkshire is brilliant!

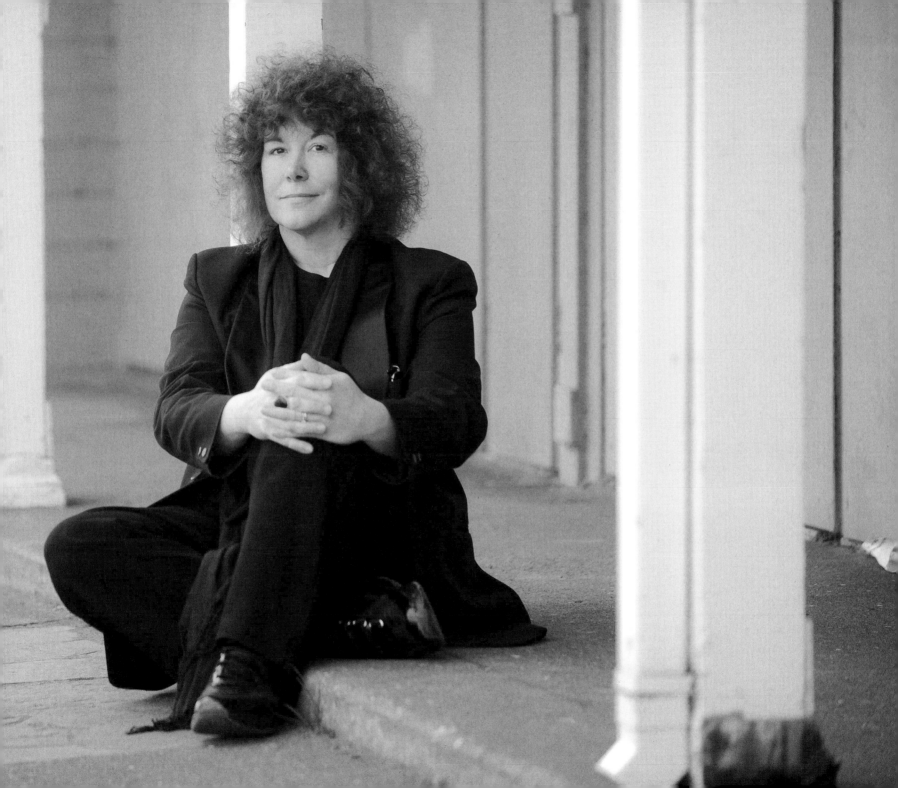

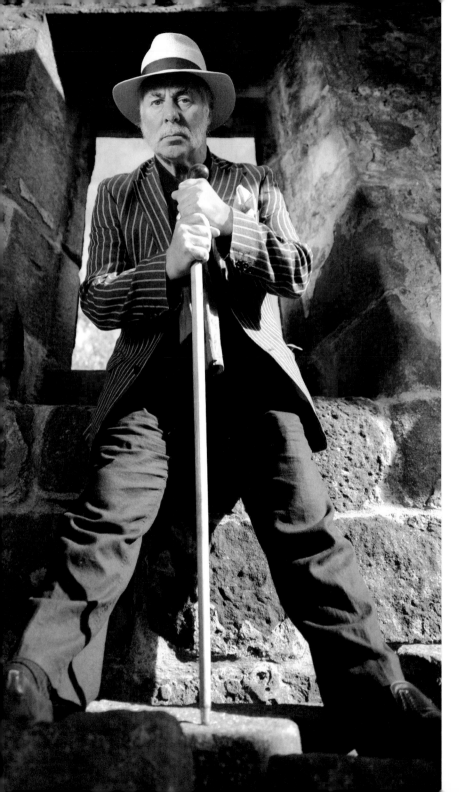

Barrie Rutter

29 AUGUST 2011 – HEPTONSTALL, WEST YORKSHIRE

Barrie Rutter – born 12 December 1946, Hull, East Riding of Yorkshire – is an actor and theatre director with a career spanning over forty years. The son of a Hull fishworker, he grew up in a two-up two-down in the fishdock area of Hull. At school, an English teacher frogmarched him into the school play because he had 'the gob for it' – he has never looked back.

He is the founder and Artistic Director of Northern Broadsides Theatre Company, which continues to perform both from its Halifax base at Dean Clough Mill and on tour nationally. He continues to play major parts in many of its productions.

Barrie has also performed in numerous productions with the Royal Shakespeare Company and the Royal National Theatre, including *Guys and Dolls*, *Henry V* and *Animal Farm*.

He has received Honorary Doctorates from the universities of Hull, Bradford and Huddersfield.

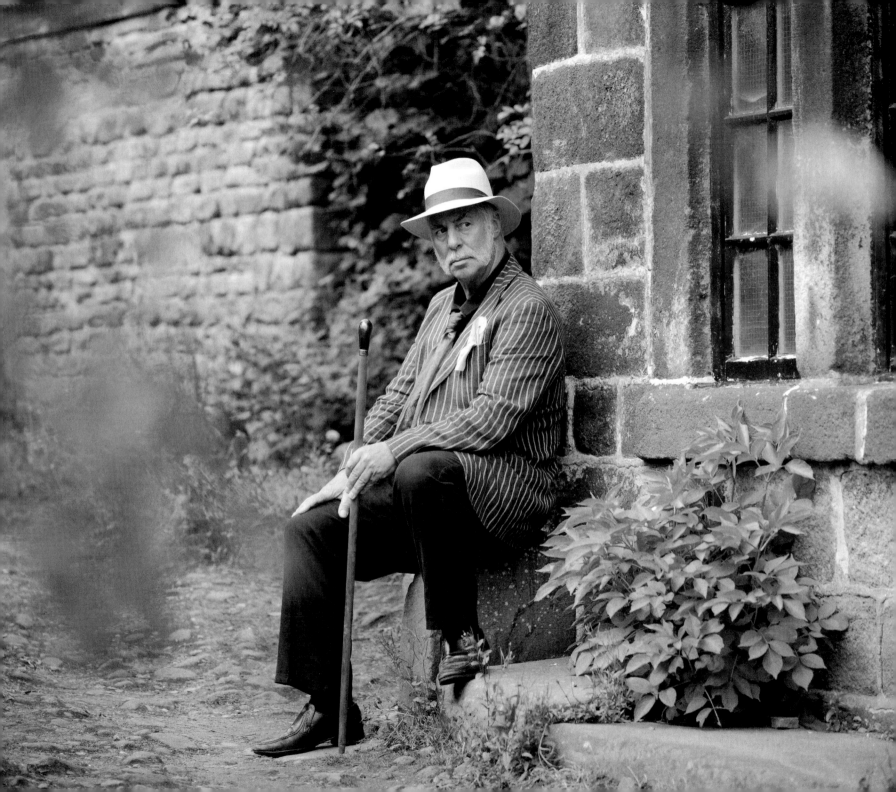

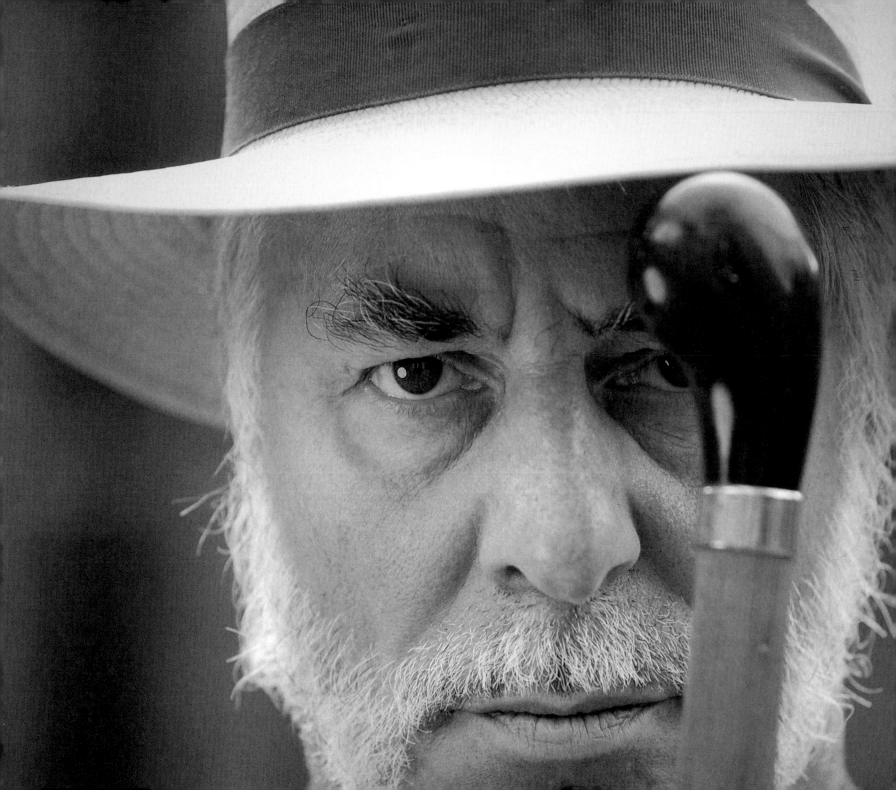

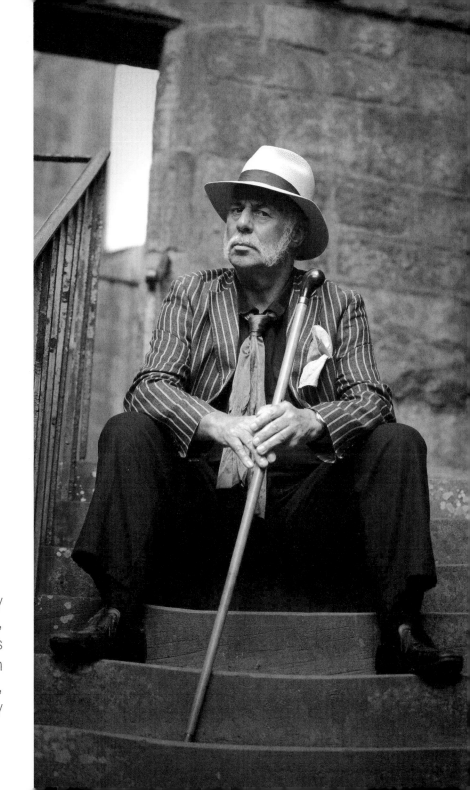

My Yorkshire? It's the creativity of hundreds of people; its size, incorporating all the various landscapes, seascapes, which directly controls accents, attitudes and industry

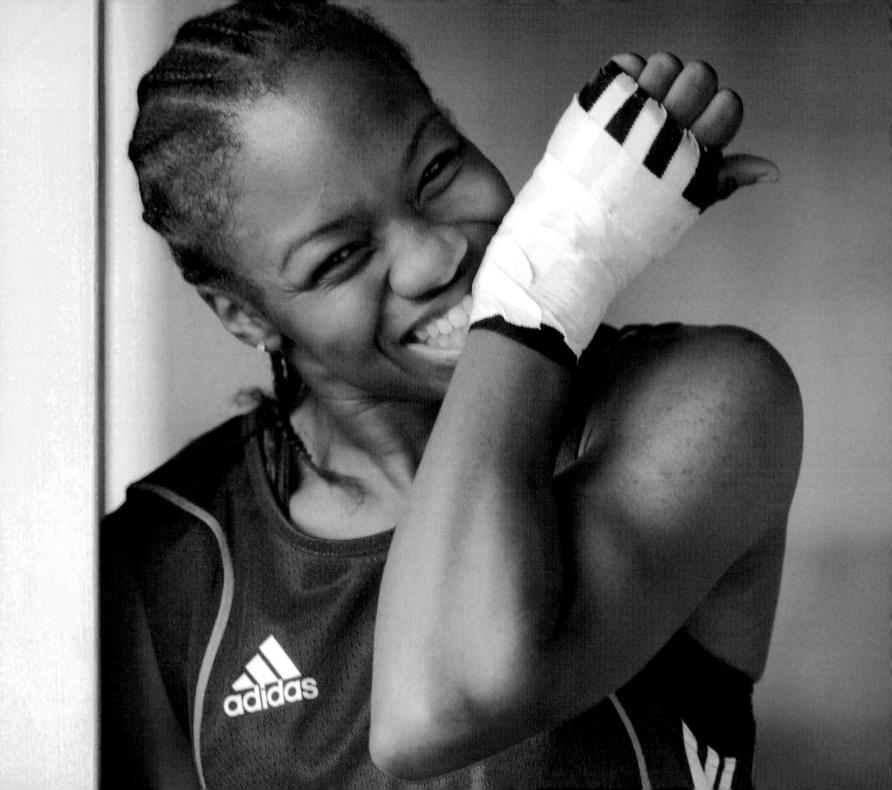

Nicola Adams

2 OCTOBER 2011 – HUGGY'S GYM, BRADFORD, WEST YORKSHIRE

Nicola Adams, MBE – born 26 October 1982, Leeds, West Yorkshire – is a boxer who made Olympic history at the London 2012 Games when she became the first woman to win an Olympic boxing gold medal.

Nicola fought, and won, her first bout at the age of thirteen. In 2001, she became the first woman boxer ever to represent England. She went on to win silver in the 2008 and 2010 World Amateur Championships, and won gold in the EU Amateur Championships.

In 2012, Nicola became the first female boxer to receive an award from the Boxing Writers' Club of Great Britain. In the 2013 New Year Honours, Nicola was appointed Member of the Order of the British Empire (MBE) for services to boxing.

Nicola is blazing the trail for inspiring future female boxers and hopes to repeat her gold medal performance at Rio in 2016.

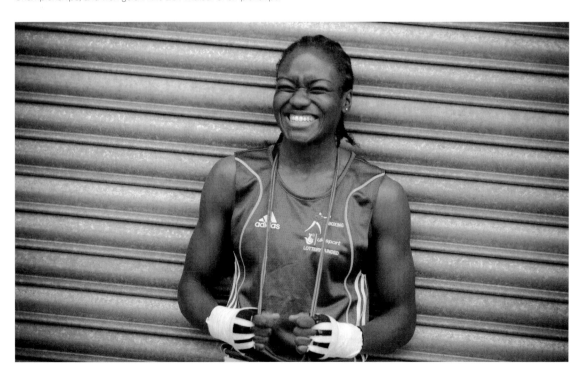

I gave my gold medal to my mum so she could get it framed

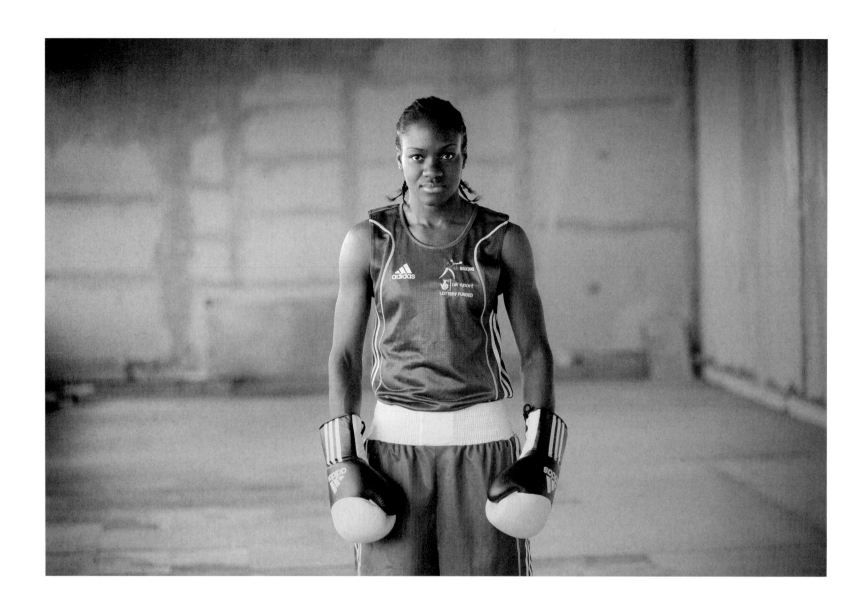

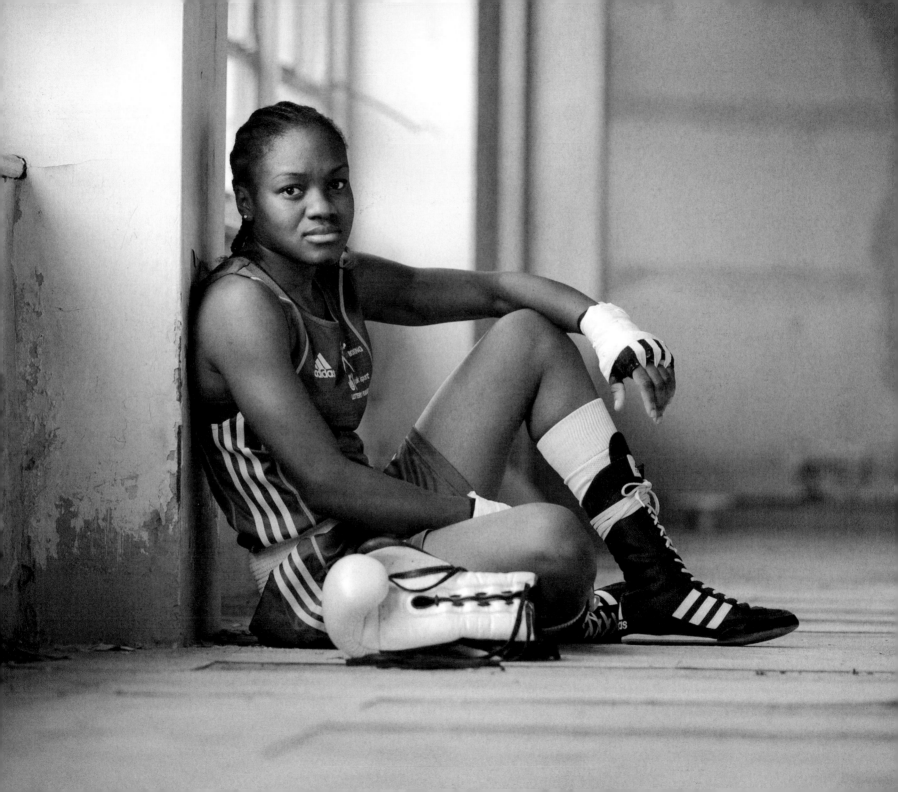

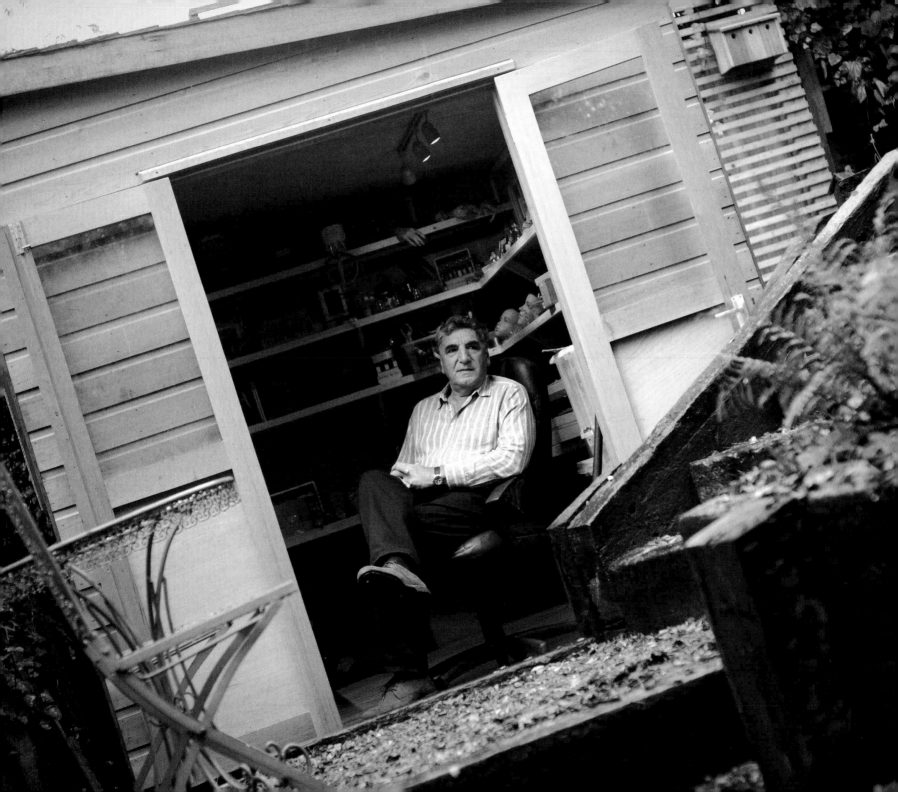

Jim Carter

Jim Carter – born 19 August 1948, Harrogate, North Yorkshire – is an actor with a career spanning over forty years.

He is well known for his role as butler Mr Carson in ITV's award-winning drama *Downton Abbey* – a role that earned him a nomination for a Primetime Emmy for Outstanding Supporting Actor in a Drama Series (2010).

His film credits include *The Madness of King George, Shakespeare in Love, The Golden Compass* and *Brassed Off* – a film about the troubles faced by a South Yorkshire colliery band following the closure of their pit.

Jim is the Chairman of Hampstead Cricket Club, which plays in the Middlesex League. For over fifty years he has been a keen cyclist, frequently riding for several charity causes and raising thousands of pounds.

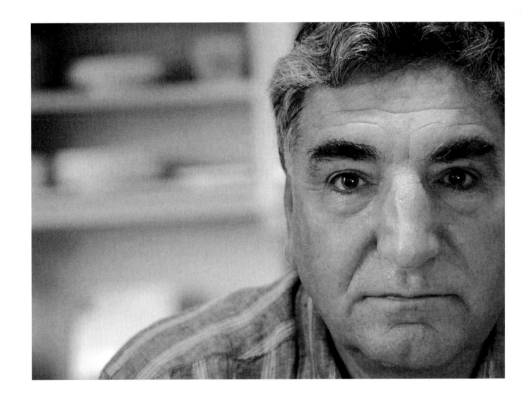

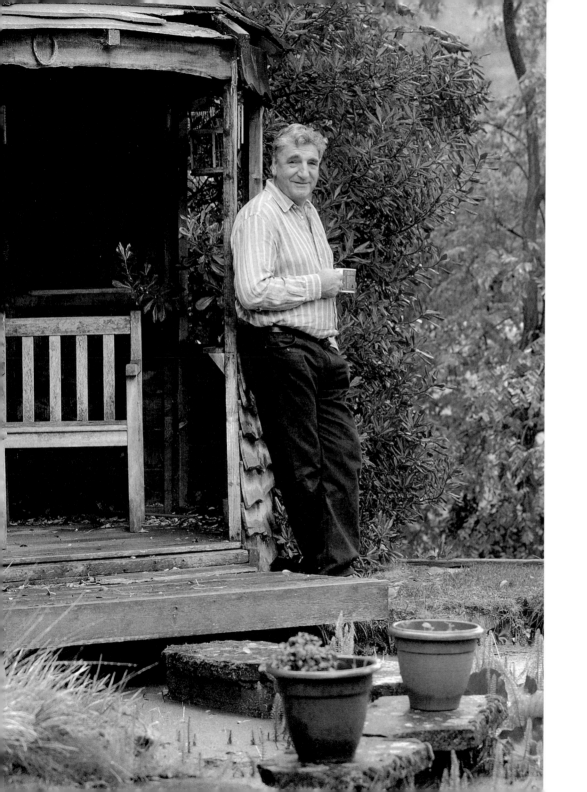

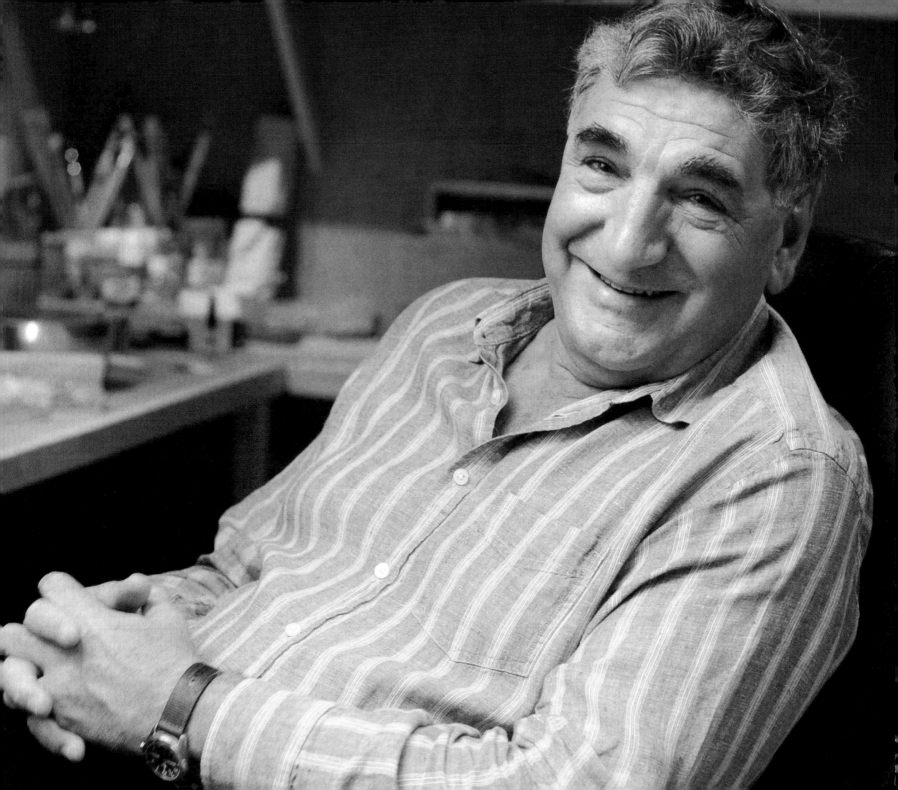

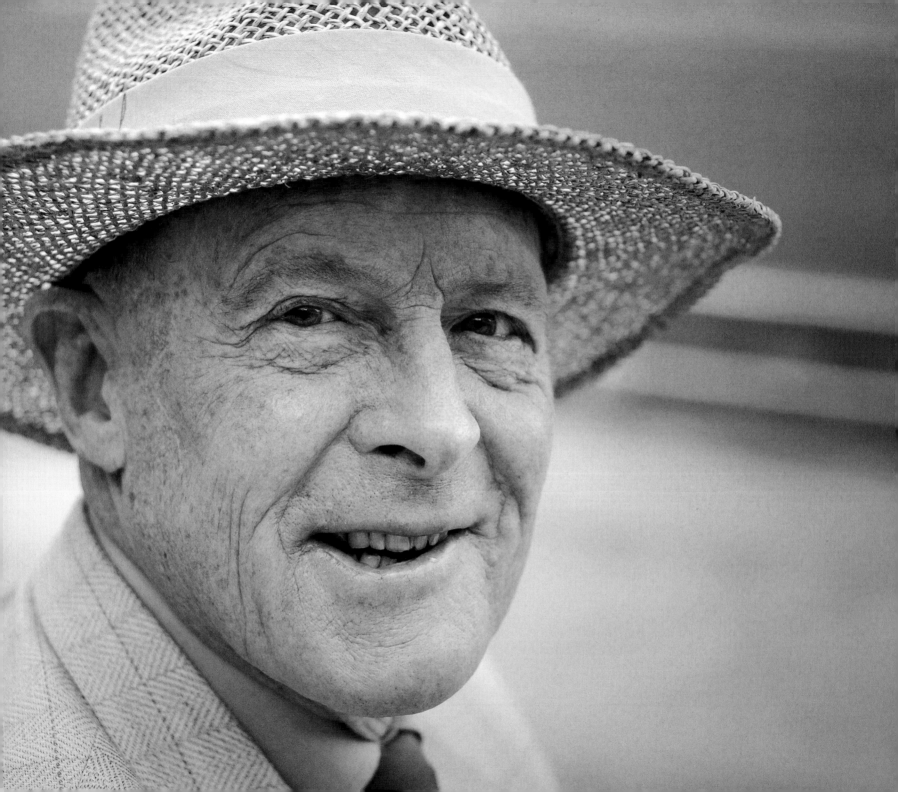

Geoff Boycott

19 SEPTEMBER 2011– HEADINGLEY CRICKET GROUND, LEEDS, WEST YORKSHIRE

Geoffrey Boycott, OBE – born 21 October 1940, Fitzwilliam, West Yorkshire – is one of England's most successful opening batsmen in a career spanning 1962–1986. Over Geoff's twenty-five-year career, he captained Yorkshire for eight seasons and scored 8,114 runs in 108 test matches for England. He was the first England cricketer to pass 8,000 runs and was introduced into the International Cricket Council's Hall of Fame in 2009. He has remained very active in cricket, including being President of Yorkshire County Cricket Club.

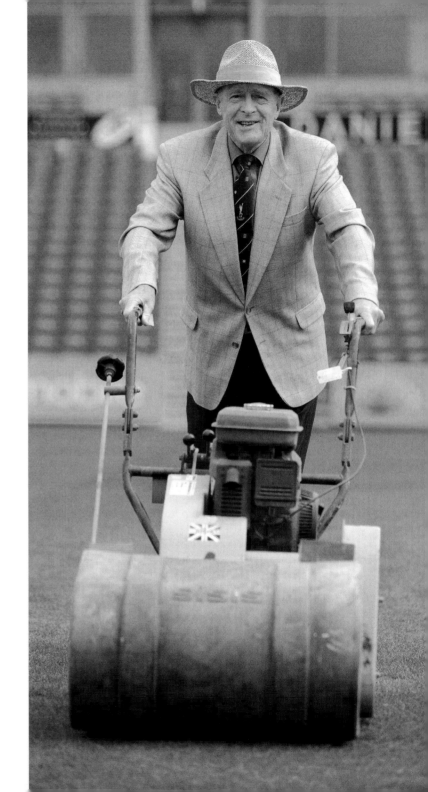

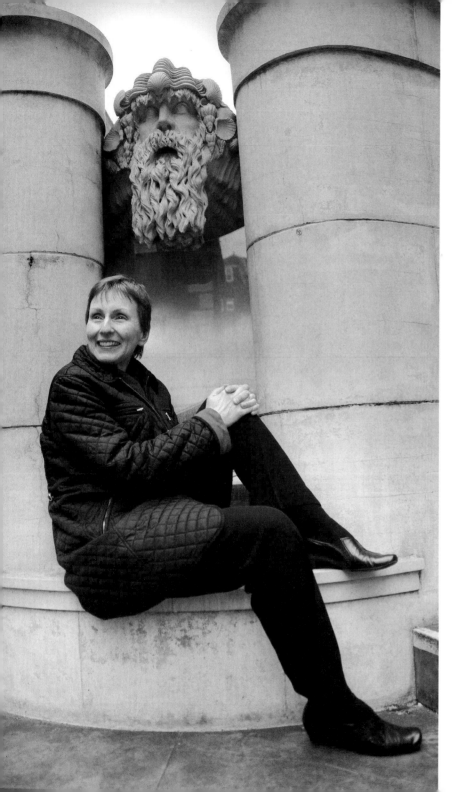

Henry Moore is the Yorkshire person I most admire, for making space in the middle mean as much as what is around it

Helen Sharman

24 JANUARY 2013 – ST PAUL'S CHURCH, COVENT GARDEN, LONDON

Dr Helen Sharman, OBE, PhD – born 30 May 1963, Grenoside, Sheffield, South Yorkshire – is a chemist. She was the first Briton in space and the first woman to visit the Mir space station when she flew aboard *Soyuz TM-12* in 1991.

Helen was selected to travel into space in 1989, beating 13,000 applicants after responding to a radio advertisement. The programme was known as *Project Juno* and was a cooperative agreement between the Soviet Union and a British company set up to manage the mission.

For her pioneering achievements, Helen was appointed an OBE in 1993. She is a Fellow of the Royal Society of Chemistry, the Royal Aeronautical Society, the British Interplanetary Society, and the Royal Geographical Society. Helen has been honoured by numerous universities including the University of Sheffield and Sheffield Hallam University.

Helen continues to work in the world of science and for many years she was one of the country's leading ambassadors for science, giving lectures around the world.

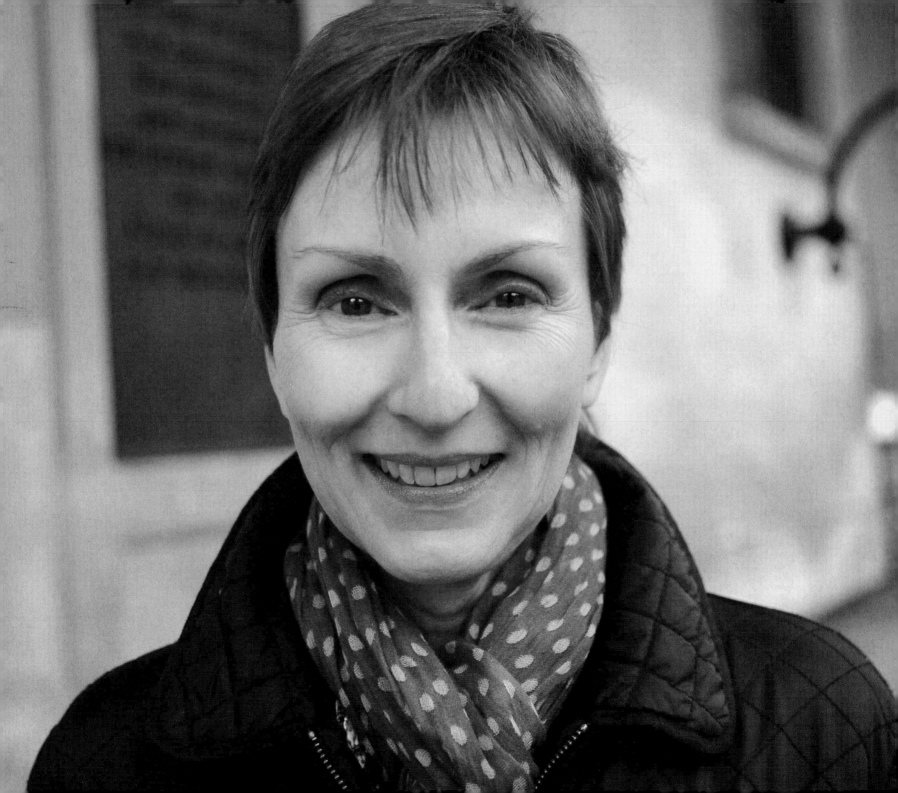

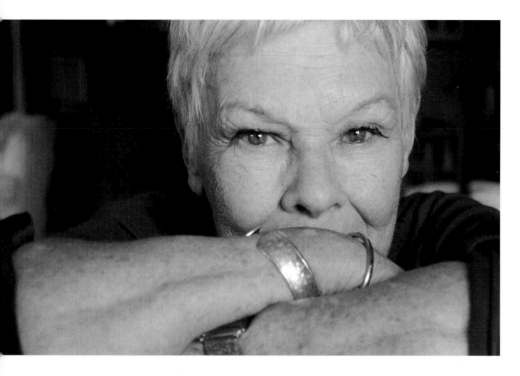

Judi Dench

26 APRIL 2012 – JUDI'S HOME IN SURREY

Dame Judi Dench, CH, DBE, FRSA – born 9 December 1934, York, North Yorkshire – is a renowned Oscar-winning actress and has developed a reputation as one of the UK's greatest actresses of the post-war period.

Judi made her professional debut in 1957 with the Old Vic Company playing Ophelia in *Hamlet* and went on to perform in numerous productions for the National Theatre Company and the Royal Shakespeare Company. In film, she is well known for her portrayal of 'M' in the James Bond films – seven of them in total – starting in 1995. In 2012, Judi made her final appearance as 'M' in *Skyfall*. Her awards include eleven BAFTAs, seven Laurence Olivier Awards, two Screen Actor Guild Awards, two Golden Globes, an Academy Award, and a Tony Award. Judi was awarded an OBE in 1970 and Dame Commander of the Order of the British Empire (DBE) in 1988 for her services to drama. She was appointed a Companion of the Order of the Companions of Honour (CH) in 2005 and in June 2011 she became a fellow of the British Film Institute.

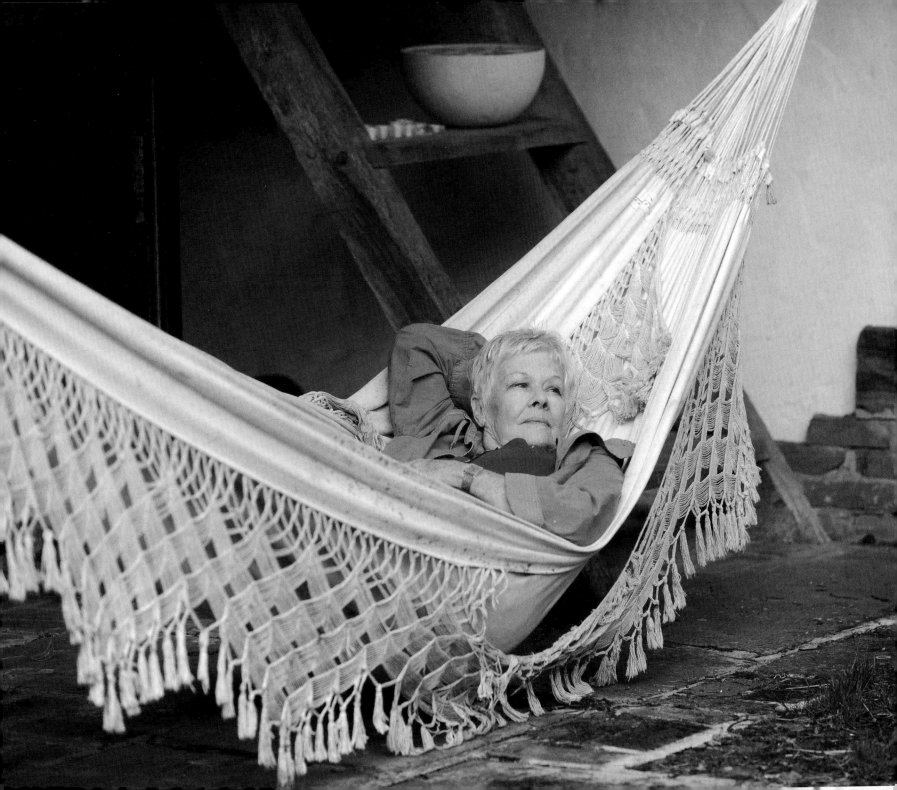

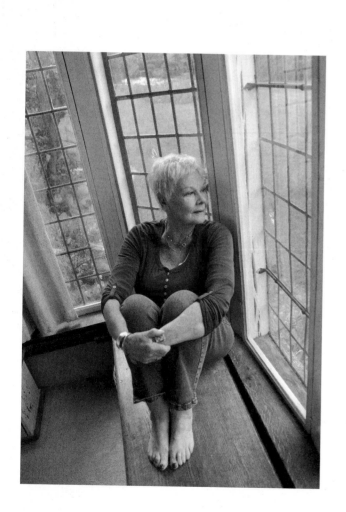

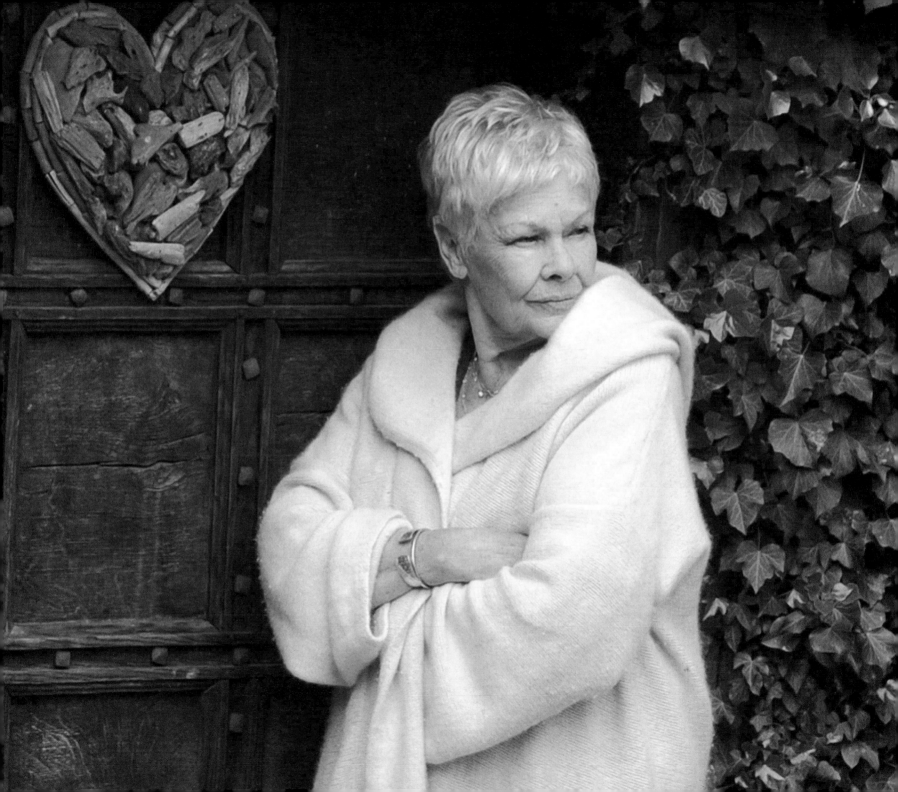

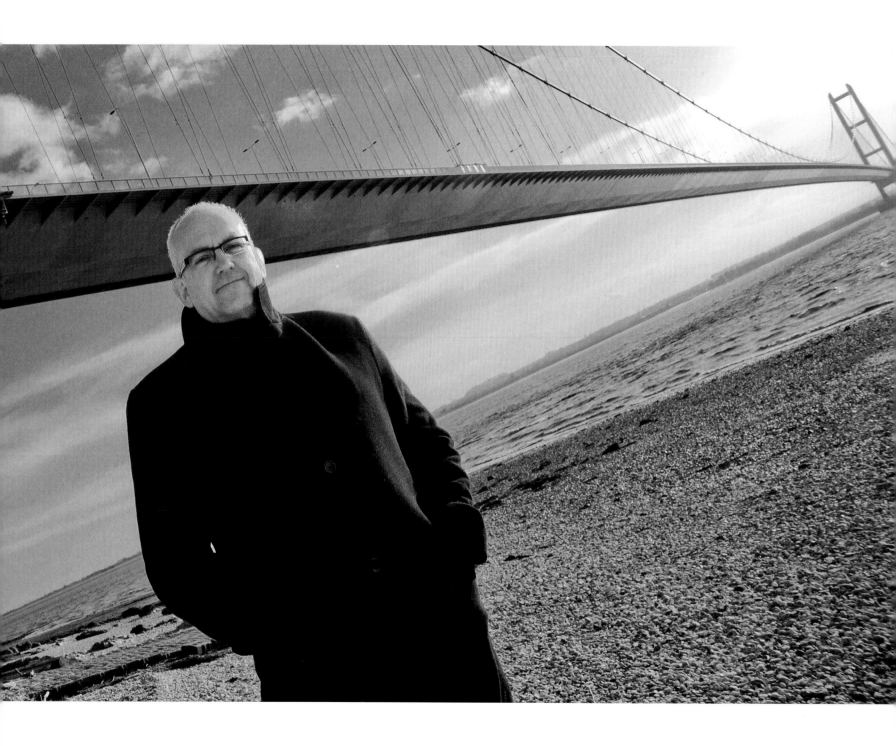

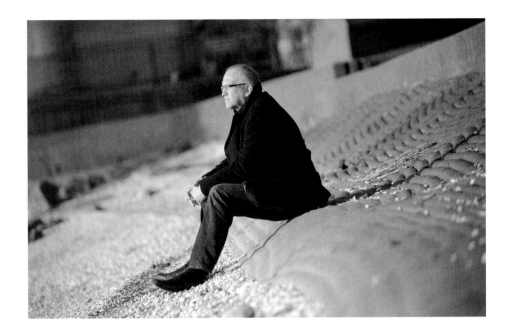

John Godber

28 DECEMBER 2011 – HUMBER BRIDGE, HULL, EAST YORKSHIRE

John Godber – born 18 May 1956, Upton, West Yorkshire – is a writer and director. His plays are performed across the world and he has the distinction of being one of the most performed writers in the English language. John was born the son of a miner and trained as a teacher of drama at Bretton Hall College, near Wakefield. He has won numerous awards for his plays including a Laurence Olivier award and seven Los Angeles Critics Circle Awards. His plays, quite often with a Yorkshire theme, include *Bouncers*, *Teechers*, *Up 'n' Under* and *Crown Prince*.

John became Artistic Director of Hull Truck Theatre Company in 1984. In 2005 he won two BAFTAs for *Odd Squad* written and directed on location in Hull and screened by BBC children's television. In the same year, John's fiftieth play, *Wrestling Mad,* marked his twenty-first anniversary with Hull Truck as Artistic Director.

John has an MA from Leeds University, he is a Professor of Contemporary Theatre at Liverpool Hope University, a visiting Professor of Drama at Hull University and a Fellow of the Royal Society of Arts.

Lesley Garrett

30 JANUARY 2012 – LESLEY'S HOME, NEAR DONCASTER, SOUTH YORKSHIRE

My philosophy is
'Spit on yer hands and
tek a fresh hold'

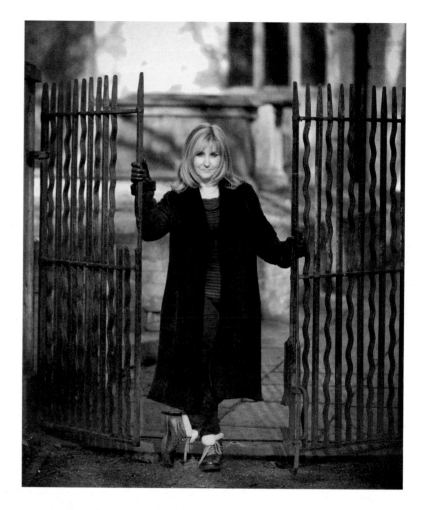

Lesley Garrett, CBE – born 10 April 1955, Thorne, Doncaster, South Yorkshire – is Britain's most popular soprano and a well-known broadcaster and media personality.

A graduate of the Royal Academy of Music, Lesley won the Decca Prize in the Kathleen Ferrier competition in 1979. In 1984 she became a principal soprano at the English National Opera. Since then she has preformed all over the world. As a recording artist she has released fourteen solo albums, many of which have achieved gold and silver status.

In 2000, Lesley became Yorkshire Woman of the Year and in 2002, she was awarded the CBE for services to music. She is a Fellow of the Royal Academy of Music and a RAM Governor. In 2013, thirty years since making her debut, Lesley made a triumphant return to Opera North in Poulenc's one-woman opera *La Voix Humaine*.

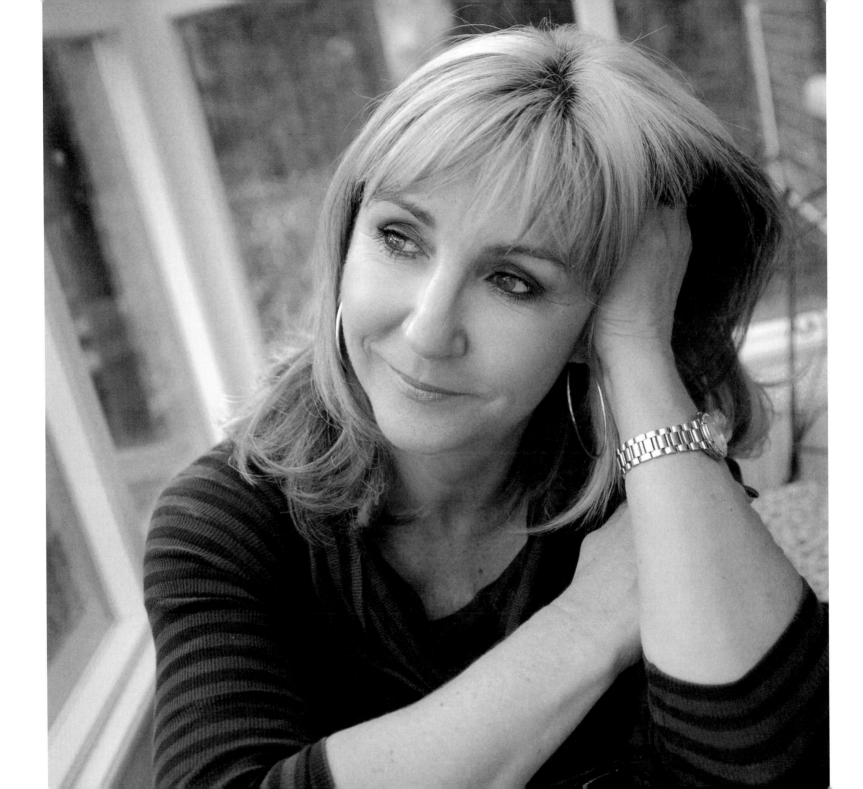

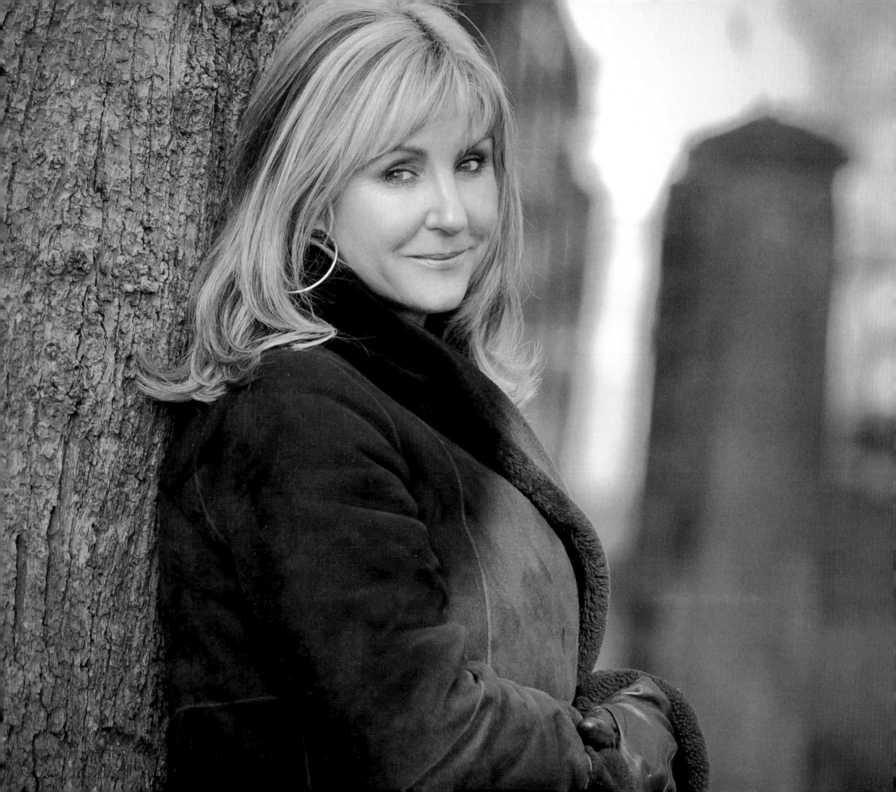

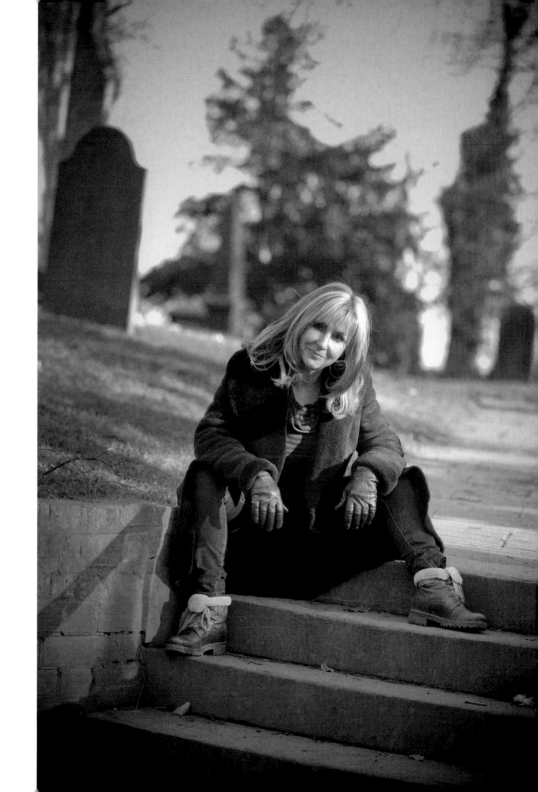

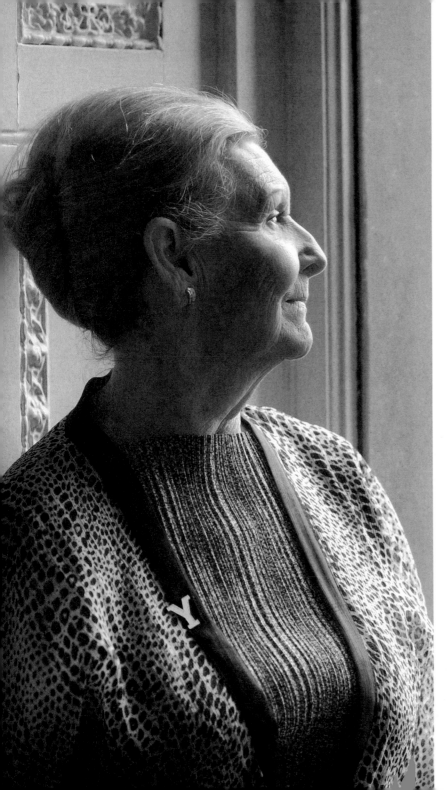

A really good Yorkshire phrase is 'If tha' knows nowt, say nowt, happen then nobody will notice!'

Mel Dyke

3 OCTOBER 2011 – BRETTON HALL COLLEGE, WAKEFIELD, WEST YORKSHIRE

Mel Dyke – born 10 April 1937, Barnsley, South Yorkshire – is an author, teacher and lecturer in Barnsley schools and colleges and was a lecturer and link tutor at Bretton Hall and the University of Leeds. Her publications include *Barnsley and Beyond*, and *All for Barnsley* – which celebrate the successful careers of people linked to the town and *Grimethorpe Revival*, a unique archive of events leading up to and resulting from the 1992 pit closures.

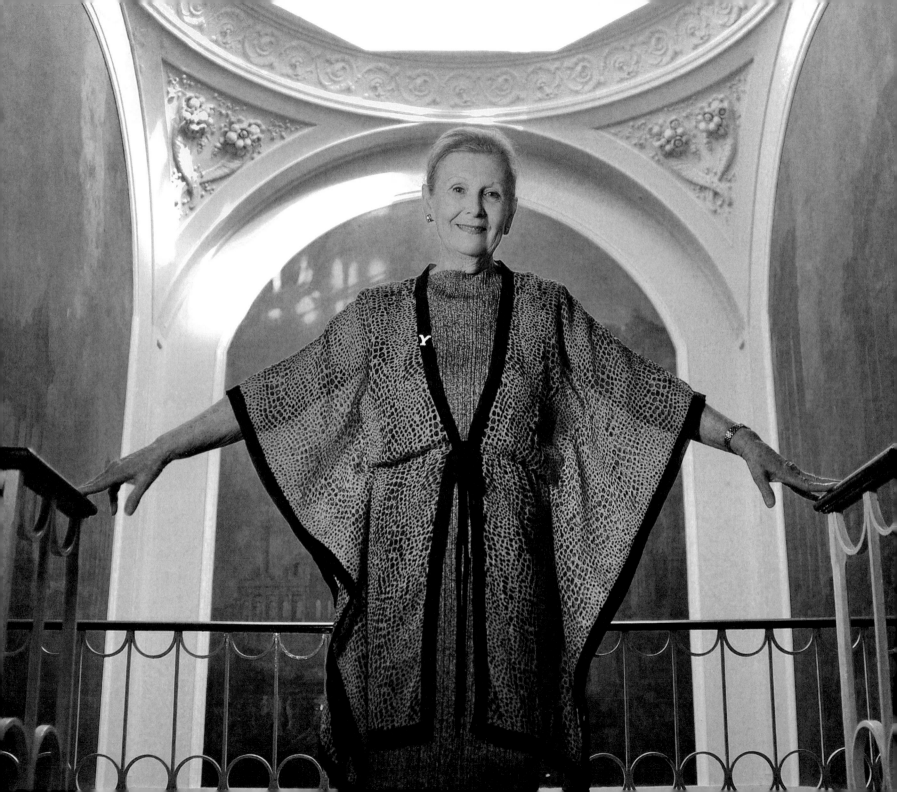

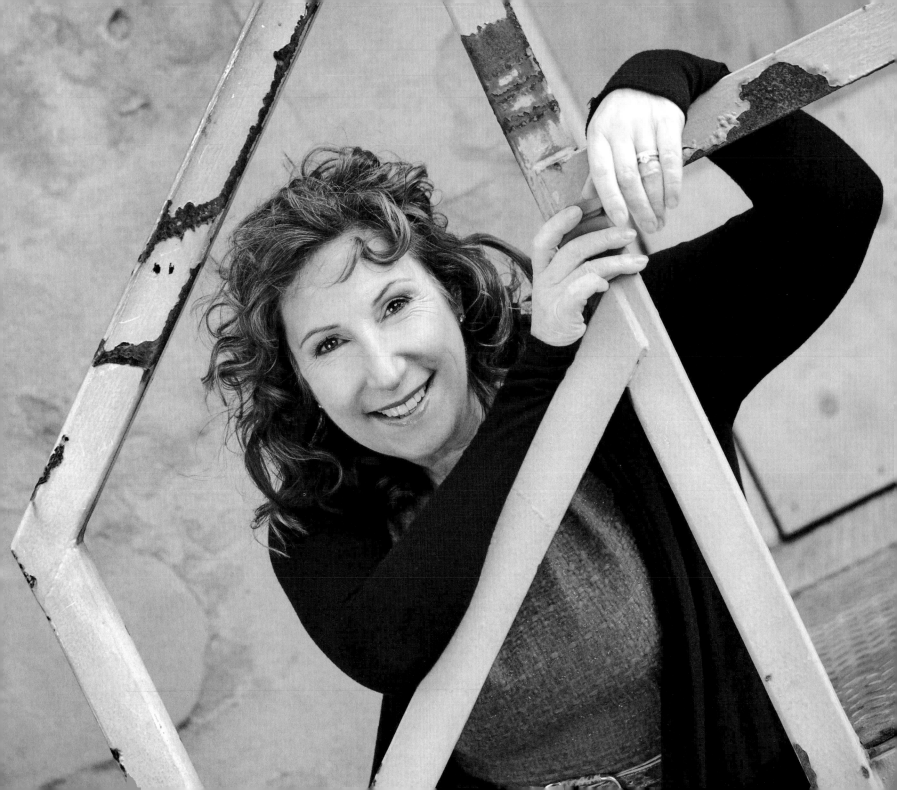

Yorkshire: a place
to be proud of,
where I feel at
home and loved

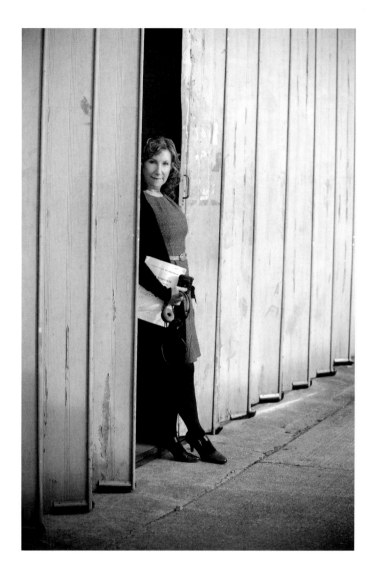

Kay Mellor

30 NOVEMBER 2011 – ON SET, *THE SYNDICATE*, LEEDS, WEST YORKSHIRE

Kay Mellor, OBE – born 11 May 1951, Leeds, West Yorkshire – is an actress, scriptwriter and director, best known for her work on several successful television dramas such as *Band of Gold*, *Playing the Field*, *Fat Friends*, *The Chase* and *The Syndicate*. Kay was appointed an OBE in the 2009 Birthday Honours. She began her career writing for *Coronation Street* – the most watched programme on the ITV network.

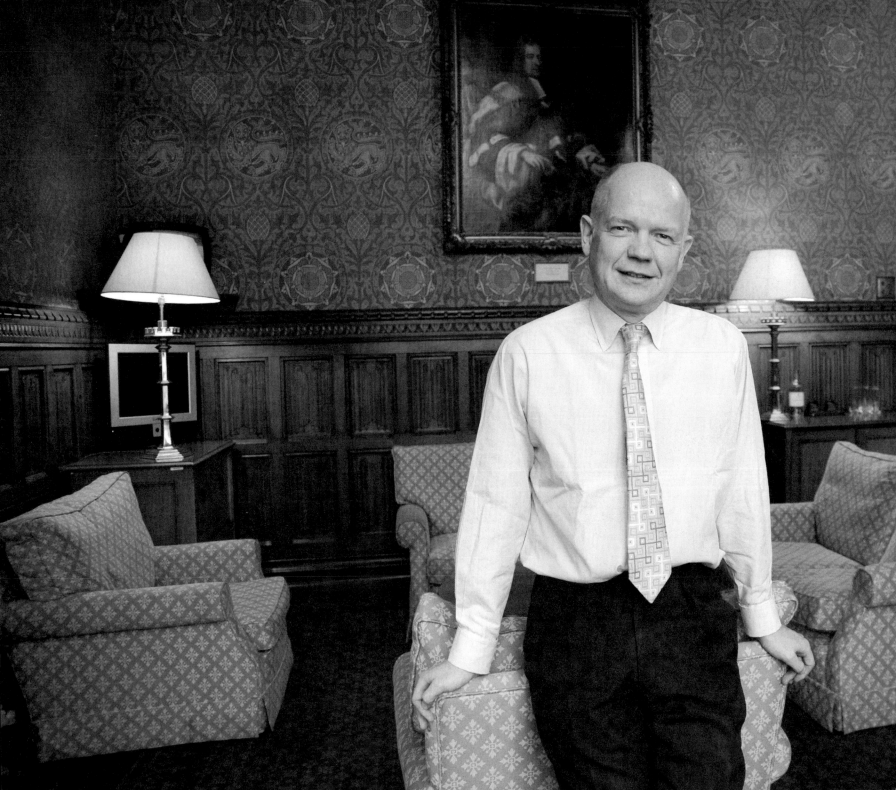

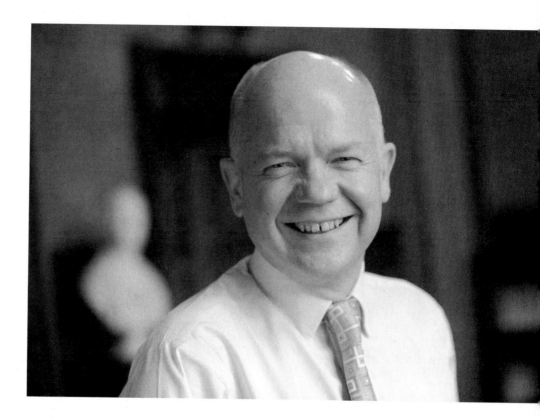

William Hague

12 OCTOBER 2011– WILLIAM HAGUE'S PRIVATE OFFICE, THE HOUSE OF COMMONS, LONDON

Rt Hon. William Hague MP – born 26 March 1961, Rotherham, South Yorkshire – is a politician who is the First Secretary of State and Secretary of State for Foreign and Commonwealth Affairs. He previously served as Leader of the Conservative Party from June 1997 to September 2001. In Parliament, he represents the constituency of Richmond (Yorkshire) having done so since 1989, when he became the youngest ever Conservative MP.

He entered John Major's Cabinet in 1995 as Secretary of State for Wales. Following the 1997 general election defeat, William was elected leader of the Conservative Party in succession to John Major.

He has written two books on British political history – a biography of William Pitt the Younger and a biography of William Wilberforce. He is a self-taught pianist and a keen enthusiast for the natural history and countryside of his native Yorkshire.

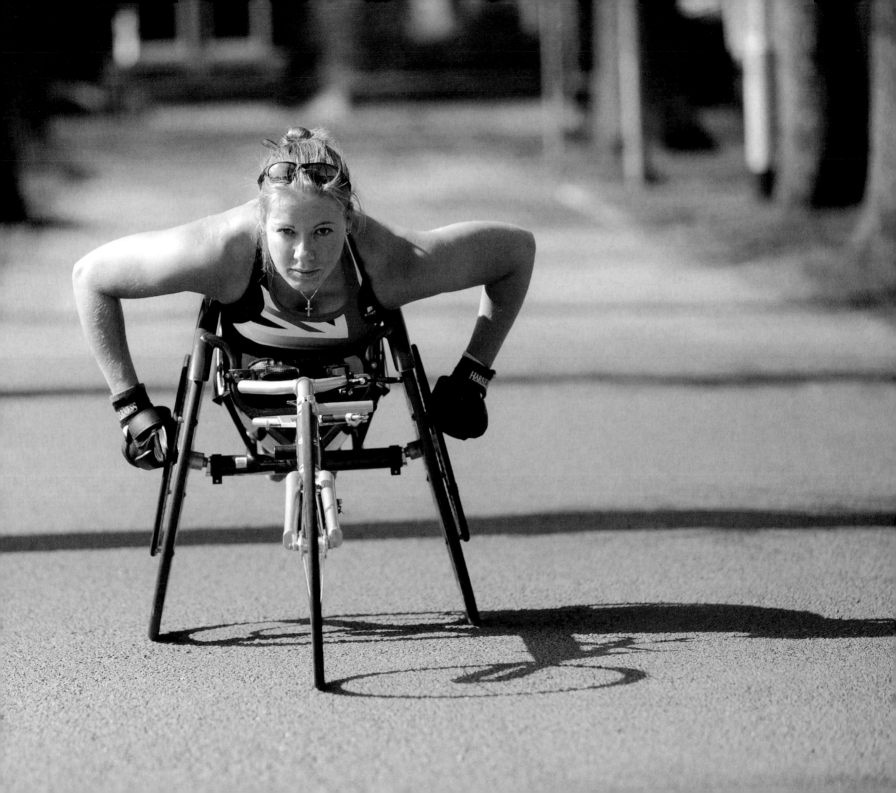

Hannah Cockroft

22 MAY 2012 – HALIFAX ATHLETICS TRACK, WEST YORKSHIRE

Hannah Cockroft, MBE – born 30 July 1992, Halifax, West Yorkshire – is a paralympic athlete. Nicknamed 'Hurricane Hannah', she holds the paralympic and world records for both the 100m and 200m T34 category. In May 2012, she became the first paralympic athlete to break a world record in the London Olympic Stadium.

Hannah went on to compete at the 2012 Summer Paralympics where she won Great Britain's first track and field gold medal at both 100m and 200m T34. Hannah is also the double World Champion and twenty-one times world record breaker. On her homecoming event to Halifax, Hannah was awarded the freedom of Calderdale.

In the 2013 New Year Honours, Hannah was appointed Member of the Order of the British Empire (MBE) for services to athletics.

In July 2013 Hannah successfully retained both her 100m and 200m titles at the IPC Athletics World Championships in Lyon.

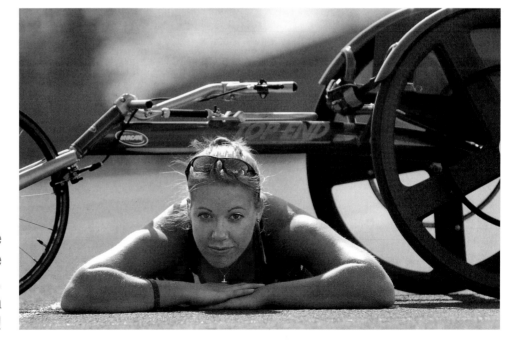

Yorkshire is the only place in the world where no-one comments on my accent, because everyone else has a proper accent just like mine!

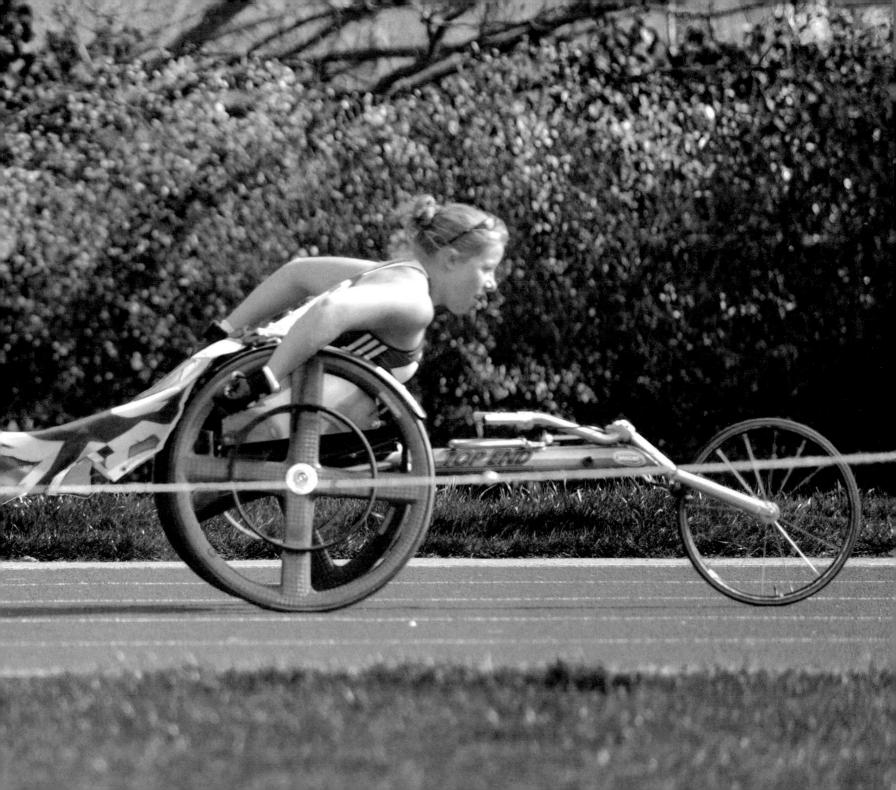

Maureen Lipman

9 AUGUST 2011 – VICTORIA PIER, HULL, EAST RIDING OF YORKSHIRE

Maureen Lipman, CBE – born 10 May 1946, Hull, East Riding of Yorkshire – is a film, theatre and television actress, columnist, author and comedienne. She studied at the London Academy of Music and Dramatic Art and made her acting debut in *The Knack* in 1969. She has since appeared in a number of West End productions including *Lost in Yonkers* and her one-woman show *Re:Joyce!* – her homage to Joyce Grenfell. She was awarded the Laurence Olivier Theatre Award for Best Comedy Performance in 1985 for *See How They Run*. She was awarded an honorary doctorate from the University of Hull in 1994 and received a Commander of the British Empire (CBE) in the 1999 Queen's New Year Honours List for her services to drama. In 2011 she was voted Yorkshire Woman of the Year.

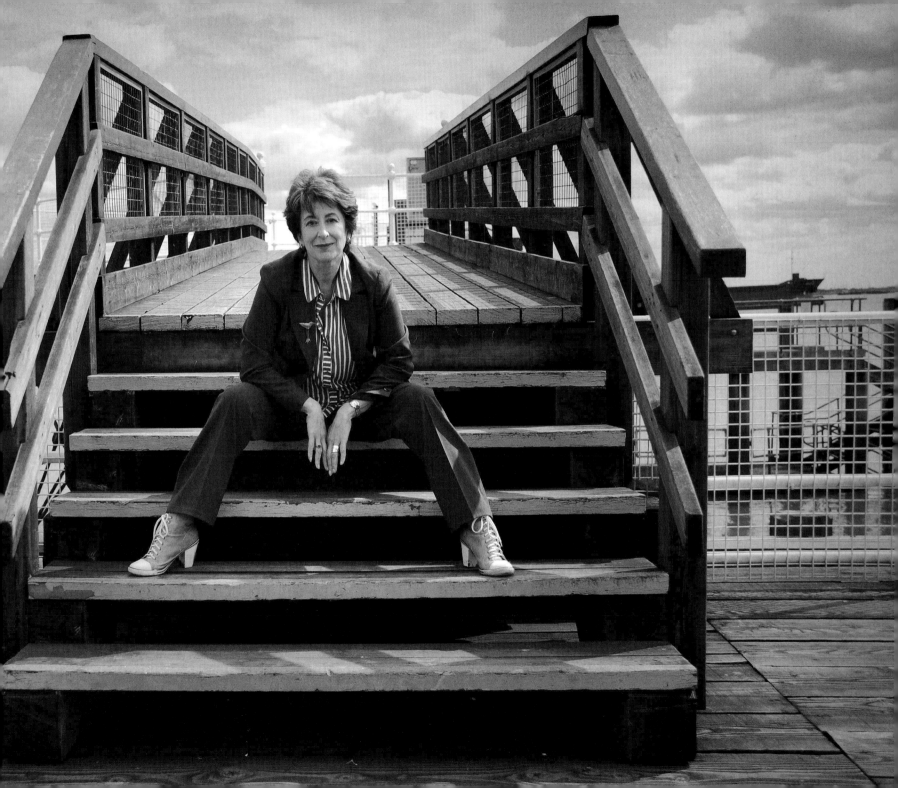

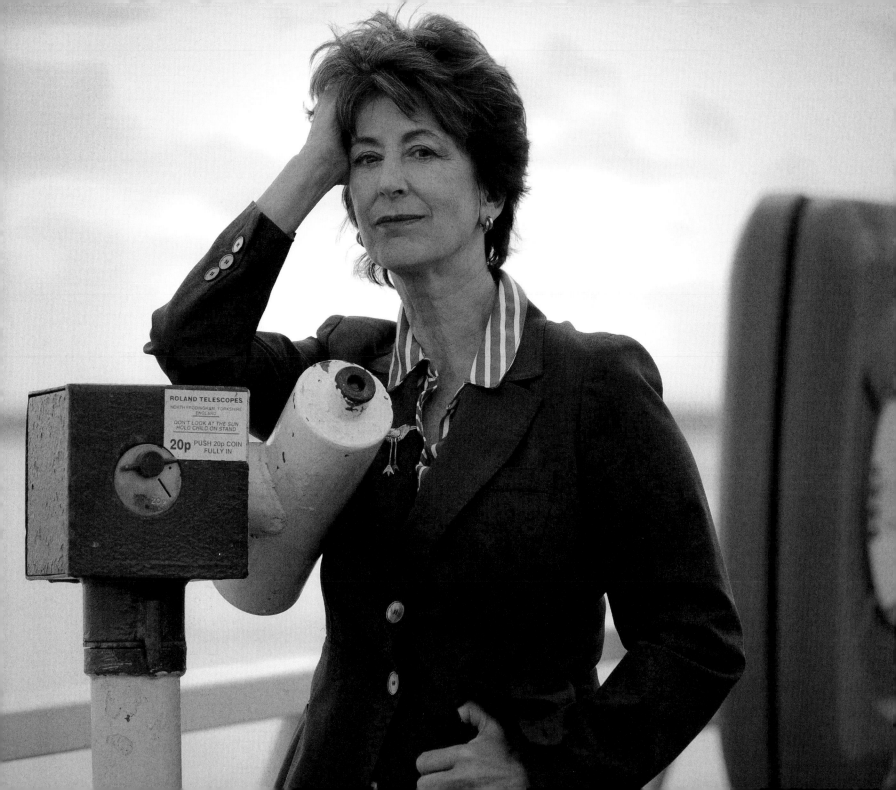

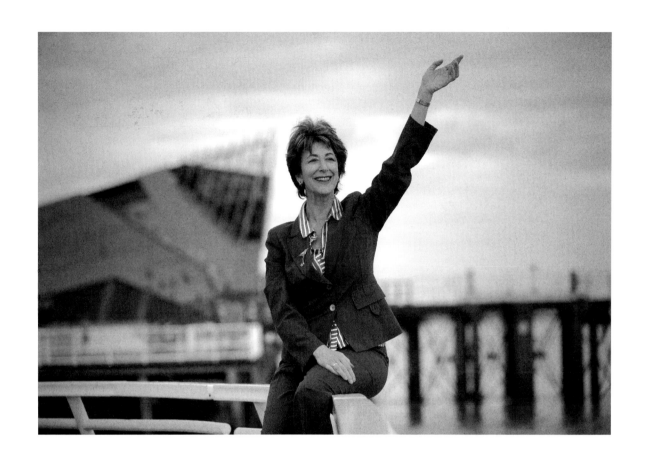

Yorkshire: it grounds me. I am blunt,
opinionated, dour, wry, funny and complex

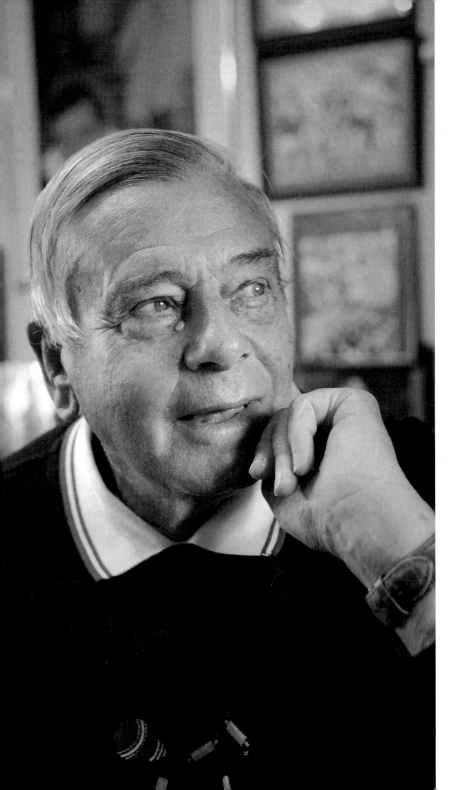

Yorkshire folk are honest
and fair – it gives our
county its unique identity

Dickie Bird

5 SEPTEMBER 2011 – DICKIE'S HOME, BARNSLEY, SOUTH YORKSHIRE

Dickie Bird, MBE, OBE – born 19 April 1933, Barnsley, South Yorkshire – is a retired international cricket umpire whose career spanned nearly fifty years.

He umpired in sixty-six test matches (at the time a world record), and ninety-three one day internationals including three World Cup finals. He went on to write his autobiography, simply titled *My Autobiography*, which sold more than a million copies.

He has also received honorary doctorates from Huddersfield, Leeds and Sheffield Hallam universities and has been given the Freedom of Barnsley.

A six-foot statue of Yorkshire's greatest ever cricket umpire has been erected in his honour near his place of birth and was unveiled on 30 June 2009.

Dickie was appointed an MBE in 1986 and in 1996 was voted Yorkshireman of the Year. In the 2012 New Year Honours he was awarded an OBE for services to cricket and charity.

His latest book, entitled *80 Not Out*, was published on his eightieth birthday in 2013.

WHITE ROSE COTTAGE

40

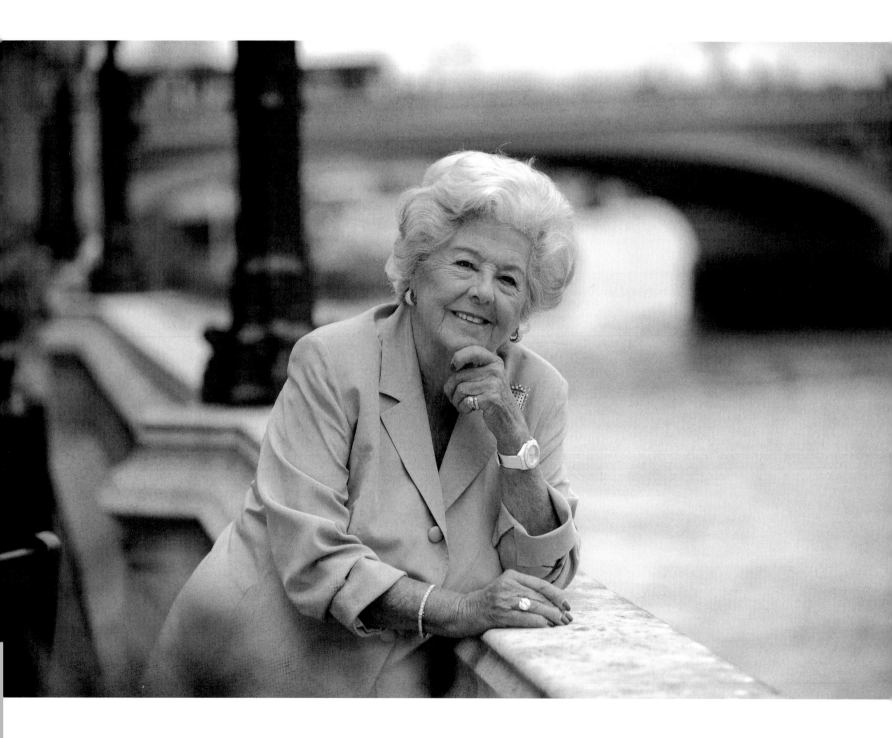

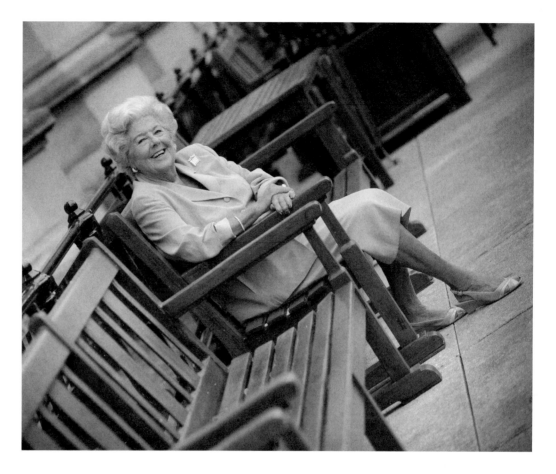

Betty Boothroyd

Just call me 'the sitter ...'

12 OCTOBER 2011 – THE TERRACE, HOUSE OF LORDS, LONDON

The Rt Hon. Baroness Betty Boothroyd, OM, PC – born 8 October 1929, Dewsbury, West Yorkshire – is a politician who served as a Labour MP for West Bromwich and West Bromwich West from 1973 to 1992. In 1992, she was elected Speaker of the House of Commons, becoming the first, and to date, only woman to ever hold the position in over 700 years of Commons history. She remained Speaker until 2000. In 2001, she was created a life peer, taking as her title Baroness Boothroyd of Sandwell in the County of West Midlands, and her autobiography was published in the same year. In April 2005, she was appointed the Order of Merit, an honour in the personal gift of the Queen.

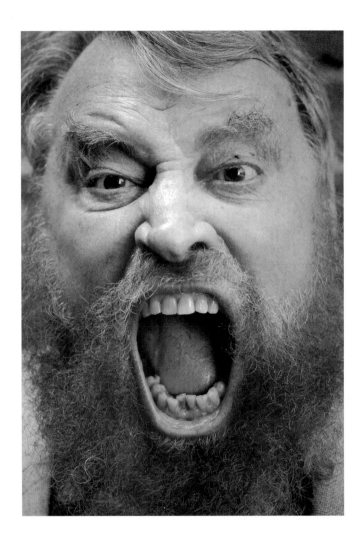

My Yorkshire
is the centre
of the earth

Brian Blessed

14 AUGUST 2012 – CROMFORD WHARF, DERBYSHIRE

Brian Blessed – born 9 October 1936, Mexborough, South Yorkshire – is an actor and author. The son of a coal miner, he trained at the Bristol Old Vic Theatre School before beginning a distinguished and varied career, which has encompassed all media. He has many television, film and stage credits, from *Z Cars*, *Blackadder* and *Flash Gordon*, to Kenneth Branagh's *Henry V* and Andrew Lloyd Webber's *Cats*.

An active mountaineer, Brian climbed Mont Blanc when he was only seventeen and has attempted to climb Mount Everest three times, climbing higher than any man of his age without oxygen. He is the oldest man ever to trek on foot to the magnetic North Pole.

He has honorary degrees from the University of Bradford, awarded in 2003, and Sheffield Hallam University in 2004. In 2011, Brian was voted Yorkshireman of the Year.

Brian is also a successful author and has written several books including *Blessed Everest*.

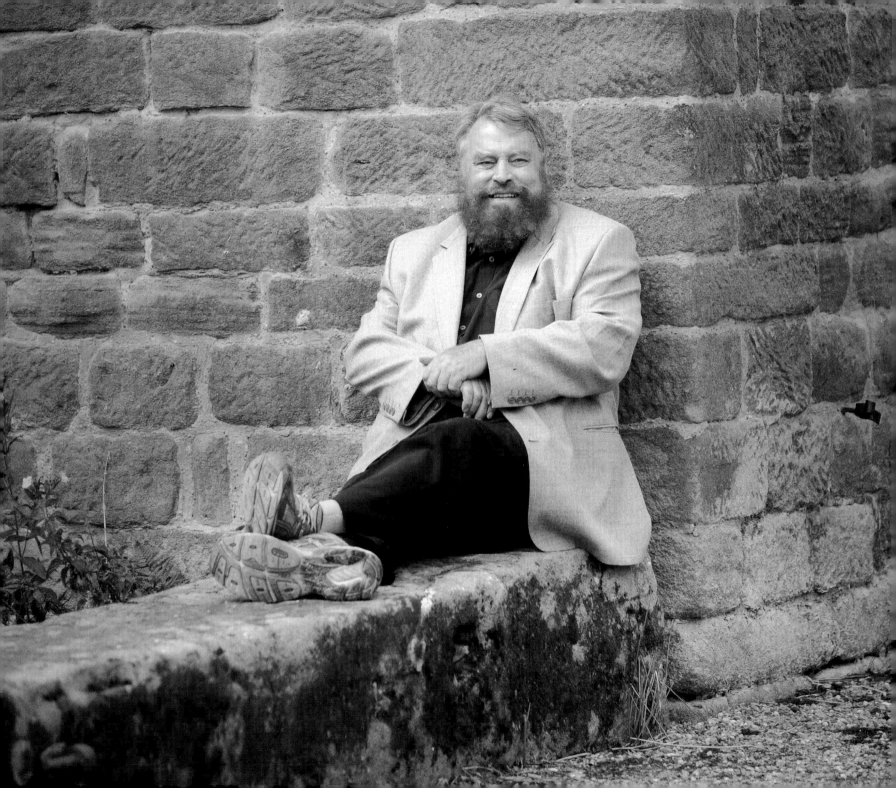

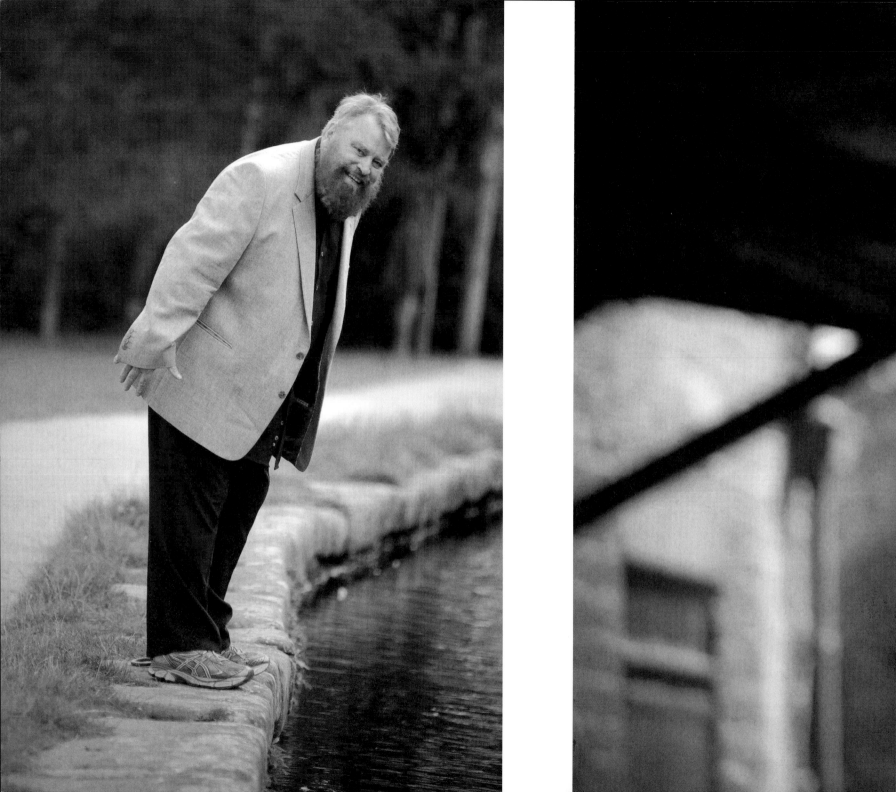

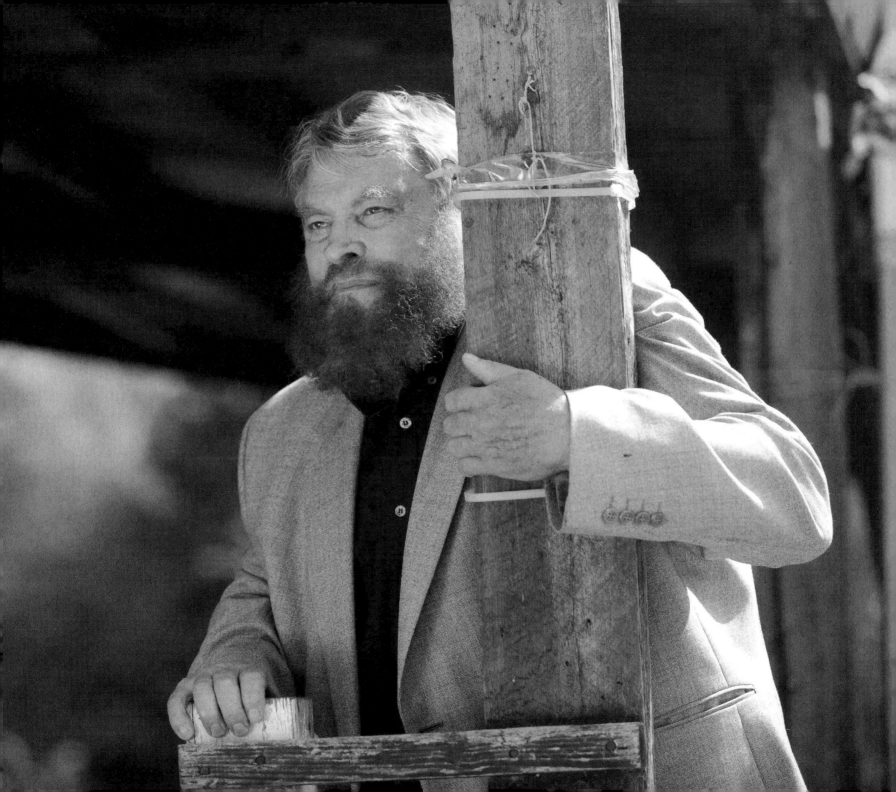

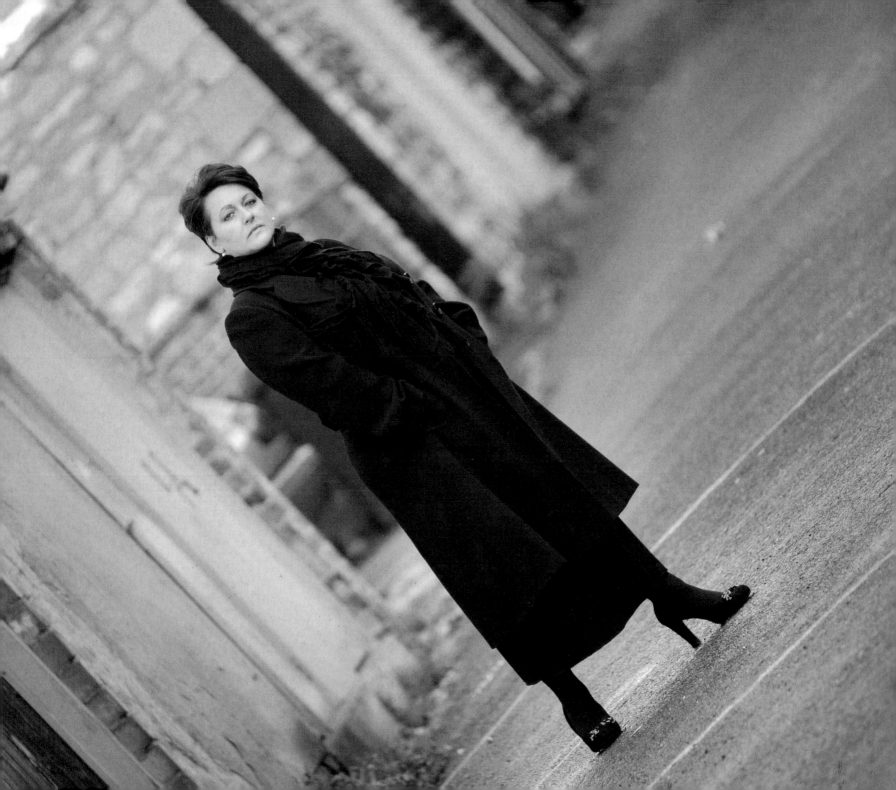

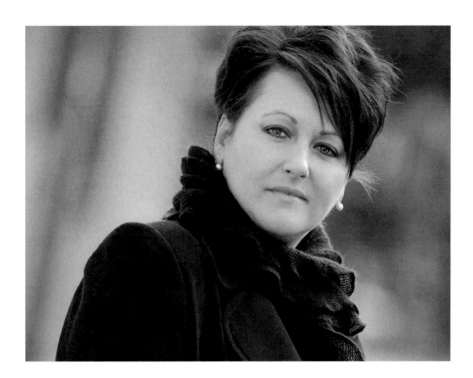

It's all about the people, the warmth
they have and the unity they share

Hayley Taylor

5 DECEMBER 2011 – HAYLEY'S OFFICES IN DONCASTER, SOUTH YORKSHIRE

Hayley Taylor – born 7 February 1967, Wakefield, West Yorkshire – is an employment expert and self-confessed 'workaholic'. Motivated, passionate, humorous and often outspoken in her opinions, Hayley has a strong desire to enforce change within the employment marketplace. She thrives on helping individuals achieve their goals and aspirations.

Hayley achieved nationwide recognition through her highly successful Channel 4 programme, *The Fairy Job Mother* – and became a household name gaining a reputation for being a 'supernanny' for the unemployed. The series went on to be a success in the USA and several other countries. In 2012, Hayley won the Yorkshire Woman of Achievement for Education.

For me, a real Yorkshire hidden gem is
Pontefract Castle – so much history

Fiona Wood

5 DECEMBER 2011 – FIONA'S FORMER HIGH SCHOOL, ACKWORTH, WEST YORKSHIRE

Winthrop Professor Fiona Wood, FRACS, AM – born 2 February 1958, Hemsworth, West Yorkshire – is a plastic surgeon now working in Perth, Australia. She is the director of the Burns Service of Western Australia and a Winthrop Professor with the School of Surgery at the University of Western Australia.

In October 2002, Fiona was propelled into the media spotlight when the largest proportion of survivors from the 2002 Bali bombings arrived at Royal Perth Hospital. She led a team working to save twenty-eight patients suffering from between 2 and 92 per cent body surface area burns.

Fiona has become well-known for her patented invention of spray-on skin for burn victims – a treatment which is being continually developed.

She was named a Member of the Order of Australia in 2003 for her work with the Bali bombing victims and Australian of the Year for 2005 by Australian Prime Minister John Howard.

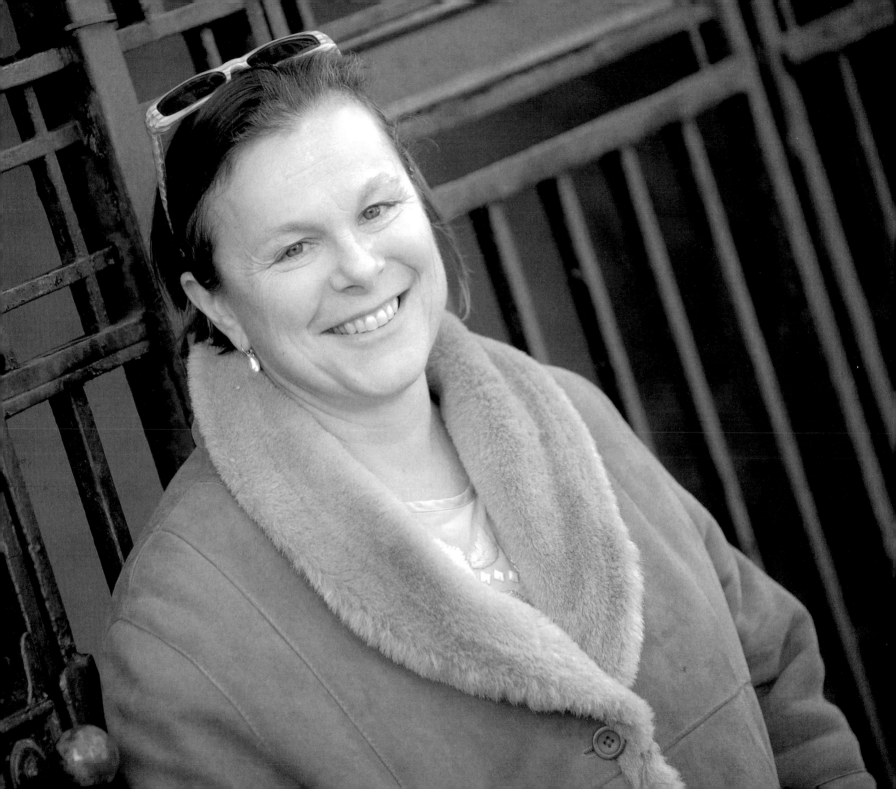

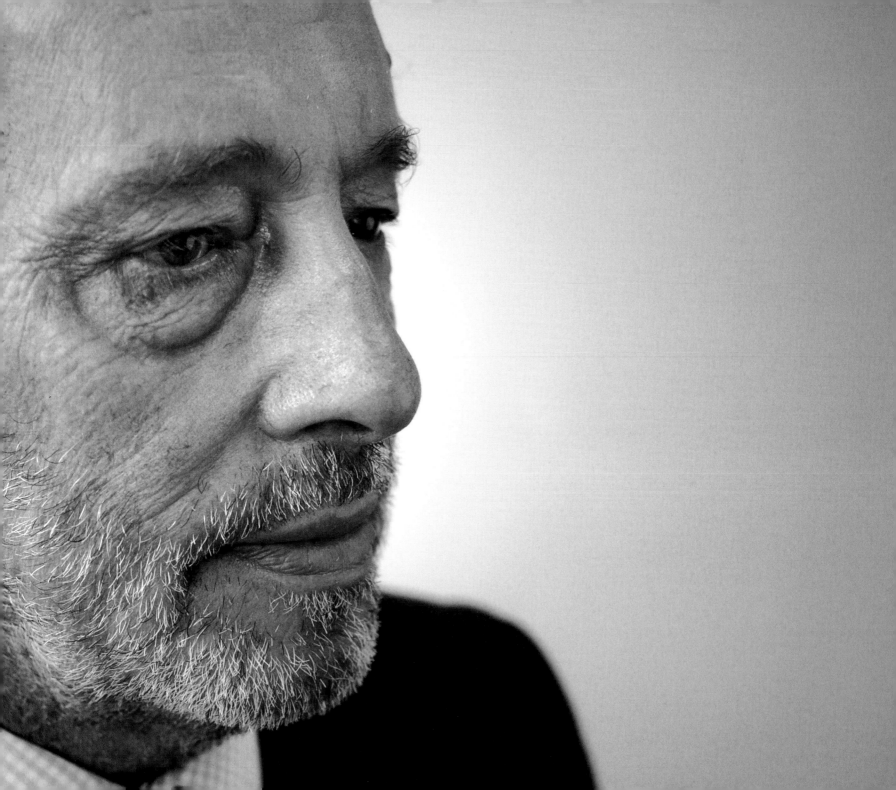

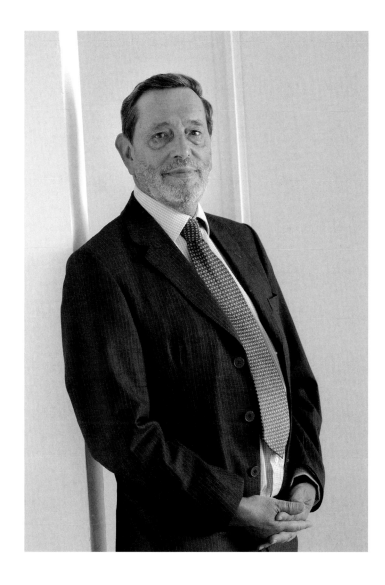

The Yorkshire person
I most admire is
Robin Hood – he
was from Loxley

David Blunkett

19 AUGUST 2011 – CONSTITUENCY OFFICES, SHEFFIELD, SOUTH YORKSHIRE

Rt Hon. David Blunkett MP – born 6 June 1947, Sheffield, South Yorkshire – is a Labour Party politician and the Member of Parliament for Sheffield, Brightside and Hillsborough. Blind since birth, and coming from a poor family in one of Sheffield's most deprived districts, he rose to become Education Secretary, Home Secretary and Secretary of State for Work and Pensions in Tony Blair's Cabinet.

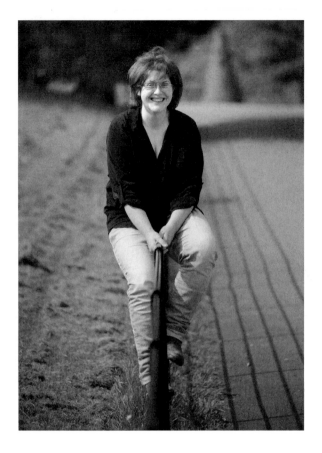

> Yorkshire influences my work all the time – massively, hugely. Almost everything I write now is set in Yorkshire. The landscape and the language are so powerful and distinctive

Sally Wainwright

23 MAY 2011 – SHIBDEN HALL, HALIFAX, WEST YORKSHIRE

Sally Wainwright – born 19 November 1963, Huddersfield, West Yorkshire – is a BAFTA-winning television writer, playwright and producer.

One of the UK's leading TV dramatists, Sally's recent successes include the popular ITV detective drama series *Scott & Bailey* and the romantic BBC comedy drama, *Last Tango in Halifax*, which won the BAFTA for best drama series in 2013.

In 2010, Sally won the Royal Television Society Award for Best Drama Serial with *Unforgiven*, and she was the creator and writer on the BAFTA- and Emmy-nominated series, *At Home with the Braithwaites*. She is renowned for using Yorkshire locations as backdrops to her dramas – her latest series for the BBC, *Happy Valley*, is set in and around Calderdale. Her other TV credits include, *Coronation Street*, *The Amazing Mrs Pritchard* and *Sparkhouse*.

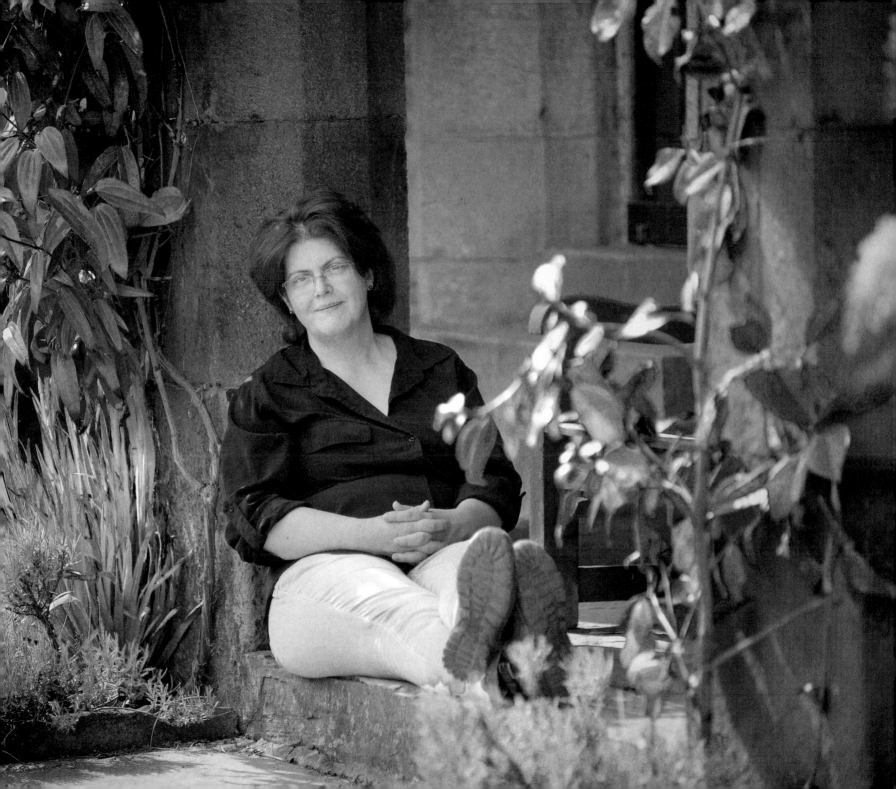

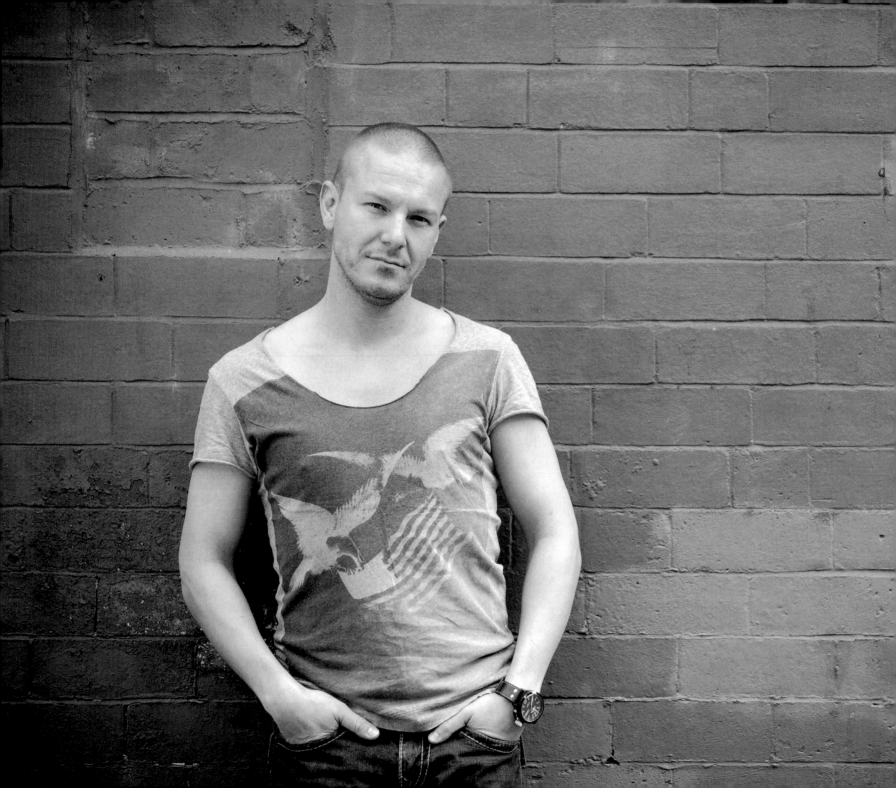

Yorkshire is my life, my playground,
my education, my world, my home

Simon Hirst

17 OCTOBER 2011 – LEEDS CITY CENTRE, WEST YORKSHIRE

Simon Hirst ('Hirsty') – born 31 July 1975, Barnsley, South Yorkshire – is a radio presenter who currently hosts the weekday breakfast show on Capital FM Yorkshire, called *Hirsty's Daily Dose*, which has recently celebrated its tenth year on air. He started his career aged twelve at Radio Aire in Leeds as a helper making tea for the DJs. He soon moved up the ranks and was on the overnight show at aged only sixteen. After shows on The Pulse, Hallam FM and Viking FM, he went on to collect a prestigious Sony Award in 2002 and again in 2006 for his work on radio.

His television work includes hosting *Hit40UK TV* on Channel 4's youth strand *T4* and documentary narration for the BBC and ITV. Simon is well-known for hosting *Hit40 UK*, the former national radio commercial chart show, which broadcast to millions each Sunday, taking over from Dr Fox in 2004.

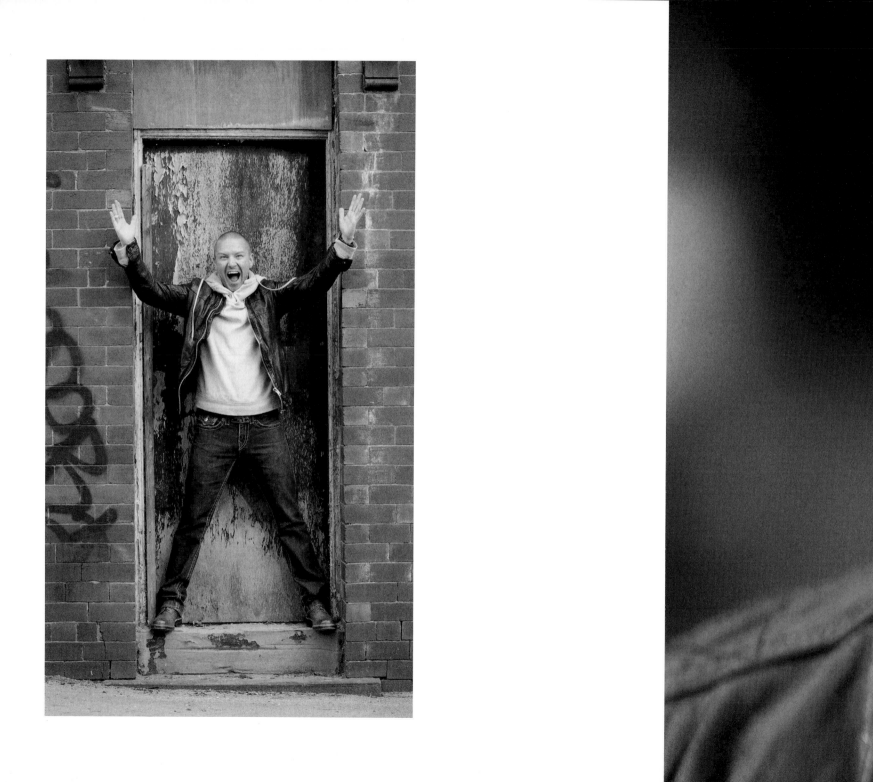

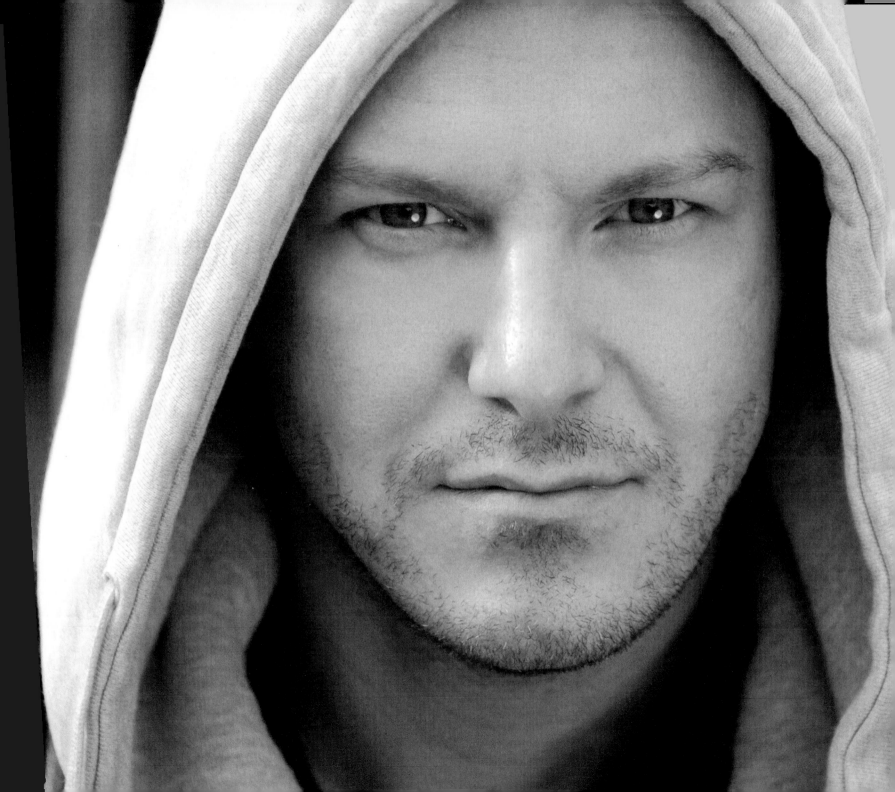

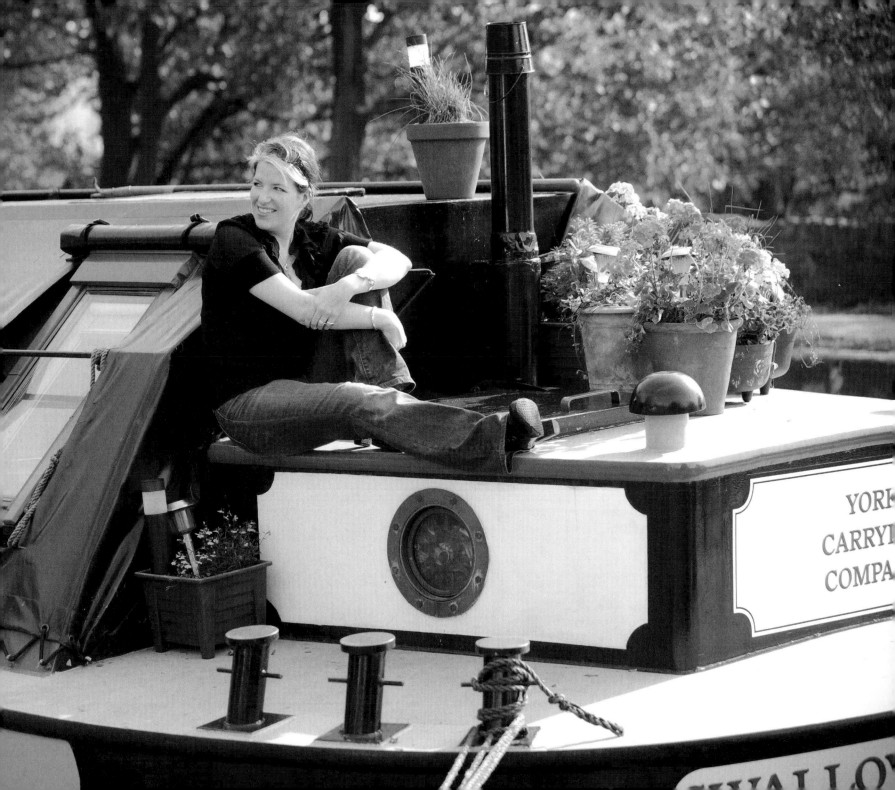

To many people, where you
are from is an irrelevance.
To me it's a badge of honour –
I'll never not be from Yorkshire!

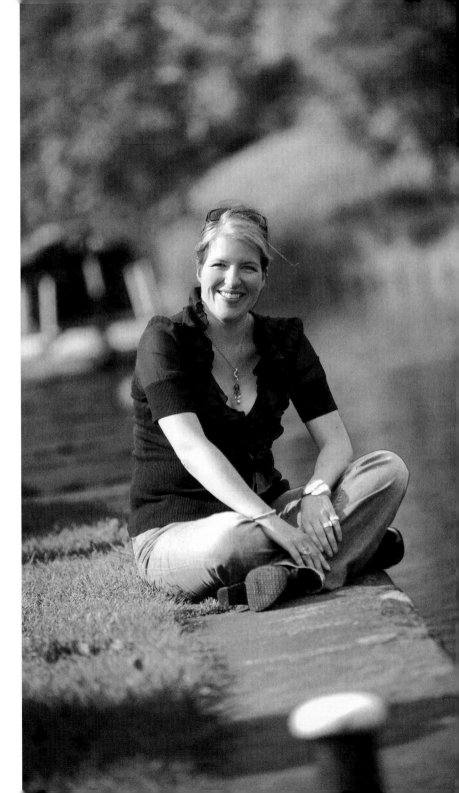

Clare Teal

1 OCTOBER 2011 – KILDWICK, NORTH YORKSHIRE

Clare Teal – born 14 May 1973, Kildwick, North Yorkshire – is one of the most successful female British jazz singers in decades, with a string of eleven successful albums under her belt. In 2004 Clare signed the biggest-ever recording contract by a British jazz singer with the Sony Jazz label. Her album of the same year, *Don't Talk*, reached number one in the UK Jazz Chart. In 2005 and 2007, Clare won British Jazz Singer of the Year and the BBC Jazz Singer of the Year in 2006. Clare also received the Arts and Personality Award at the Yorkshire Awards 2011.

Alongside her music, Clare has a successful career in broadcasting, presenting *Clare Teal*, Sunday nights, and *Big Band Special*, Monday nights for Radio 2. She also contributes a weekly column to her beloved *Yorkshire Post*.

Brian Robinson

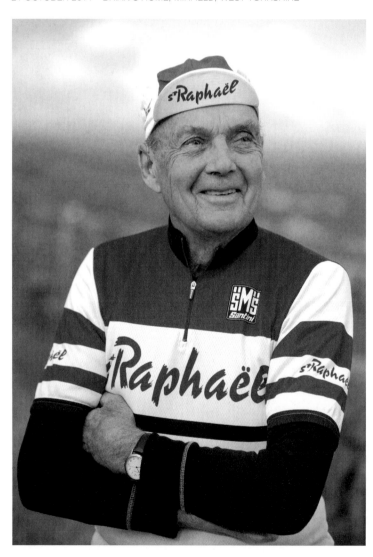

Brian Robinson – born 3 November 1930, Dewsbury, West Yorkshire – is a former road bicycle racer of the 1950s and early 1960s. He was the first Briton to finish the Tour de France in 1955 and the first Briton to win a Tour stage in 1958.

He joined Huddersfield Road Club when he was thirteen, and completed much of his early racing during his National Service. In addition to his Tour success, Brian also won the Critérium du Dauphine Libéré in 1961.

In 2009, Brian was inducted into the British Cycling Hall of Fame. He has been one of the key figures in support of bringing the Tour de France Grand Départ to Yorkshire. The legendary cyclist has been immortalised on a series of stamps to mark the 100th anniversary of the Tour de France.

Fifty-one years since retiring from the sport, he still rides forty miles every Saturday and Wednesday.

Get thissen ossed

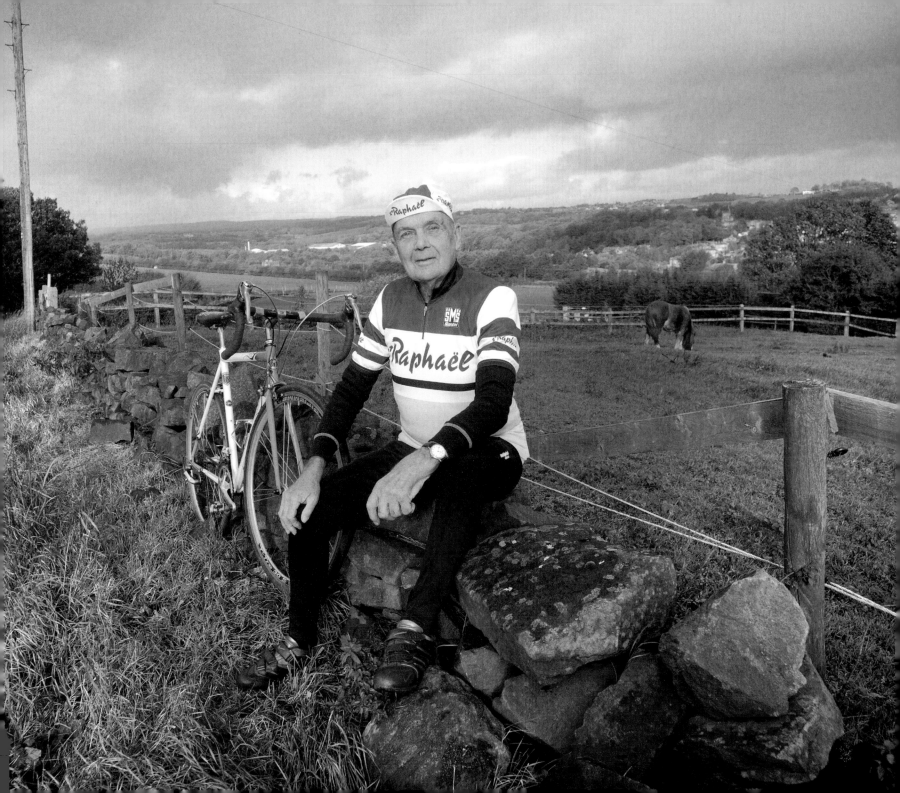

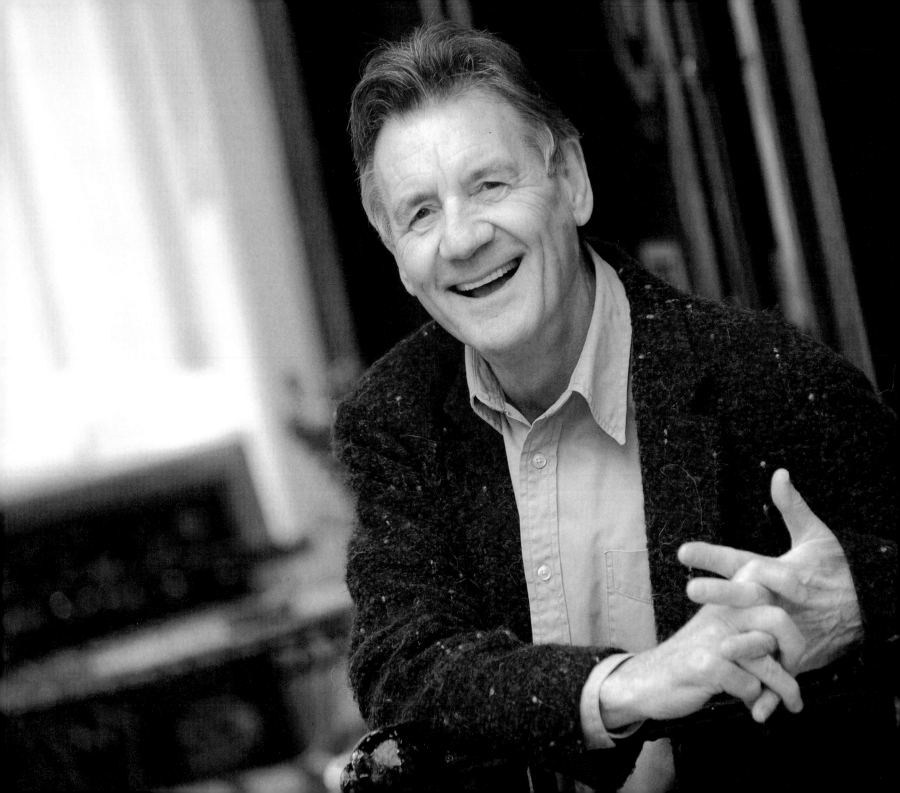

Michael Palin

16 DECEMBER 2011 – COVENT GARDEN, LONDON

Michael Palin, CBE, FRGS – born 5 May 1943, Sheffield, South Yorkshire – is a comedian, actor, writer and television presenter best known for being a member of the comedy group Monty Python and for his travel documentaries.

He has also appeared in several films, including *A Fish Called Wanda*, for which he won a BAFTA for Best Supporting Actor. After Python, Michael began a new career as a travel writer and travel documentarian.

His journeys have taken him across the world, including the North and South Poles, the Sahara desert, the Himalayas and most recently Brazil.

In 2000, Michael was honoured as a CBE for his services to television. From 2009 to 2012, Michael was the president of the Royal Geographical Society.

In 2013, Michael was awarded the BAFTA Fellowship, BAFTA's highest honour.

See all,
hear all,
say nowt!

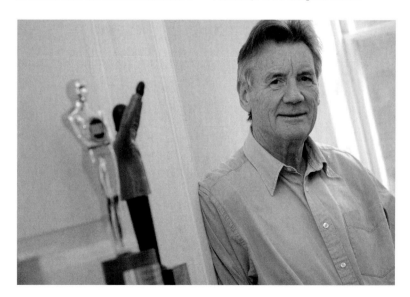

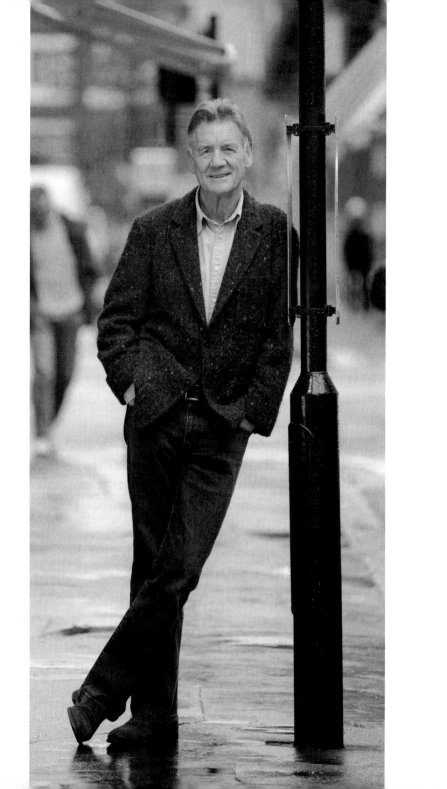

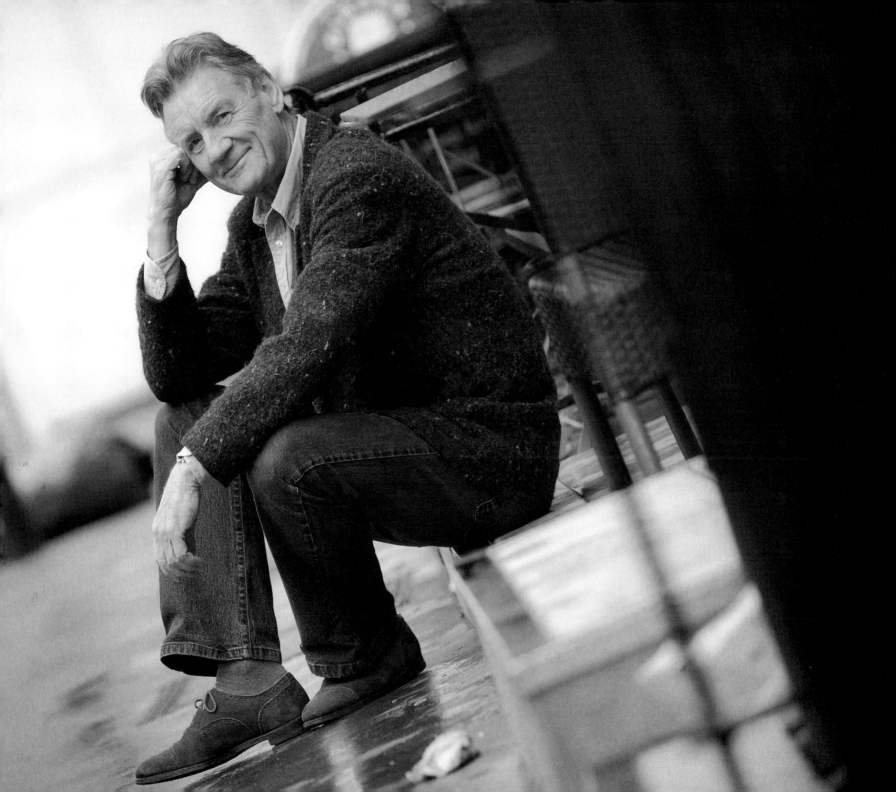

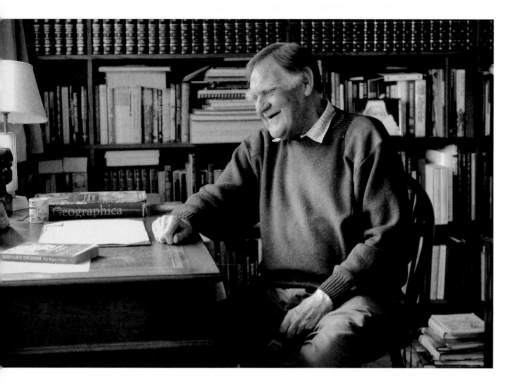

My favourite Yorkshire saying is 'Nay lad' – it usually precedes a lesson on how to do something properly!

Bernard Ingham

11 MARCH 2012 – BERNARD'S HOME, PURLEY, SURREY

Sir Bernard Ingham – born 21 June 1932, Hebden Bridge, West Yorkshire – is a journalist, broadcaster and former Chief Press Secretary to Prime Minister Margaret Thatcher.

Bernard spent eleven years at 10 Downing Street and travelled half a million miles with the Prime Minister, briefing the press on her behalf at thirty-one European and eleven Economic summits and six Commonwealth conferences.

Baroness Thatcher called him 'the best press secretary in the world'. He started his career in journalism at the age of sixteen on the *Hebden Bridge Times* newspaper. Bernard went on to be the Northern Industrial Correspondent of the *Yorkshire Post* and on the labour staff of the *Guardian*.

He was knighted on Margaret Thatcher's resignation and retirement in 1990.

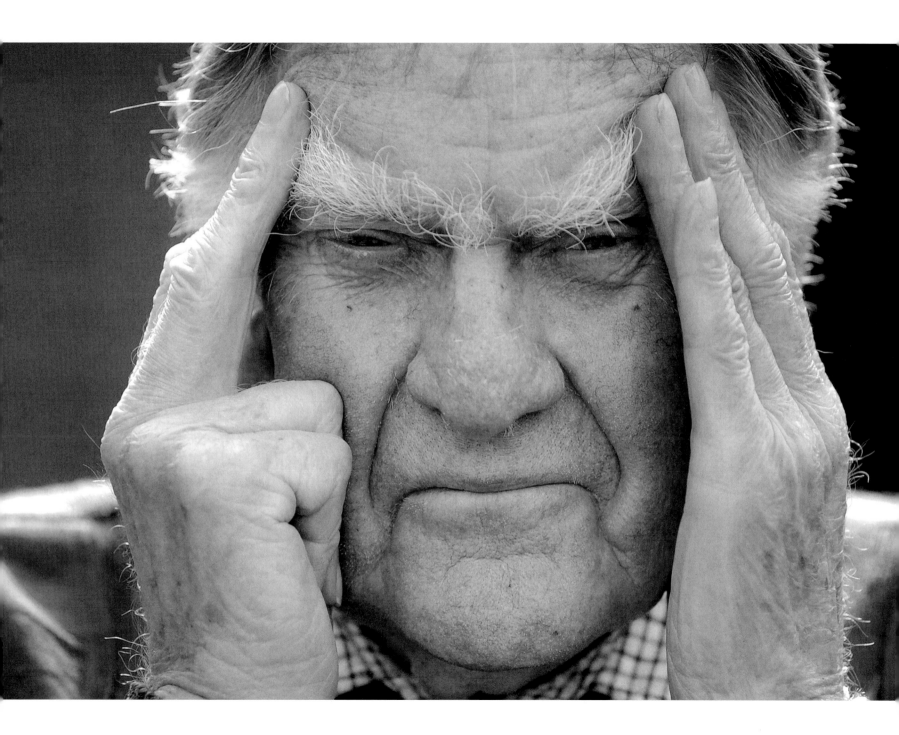

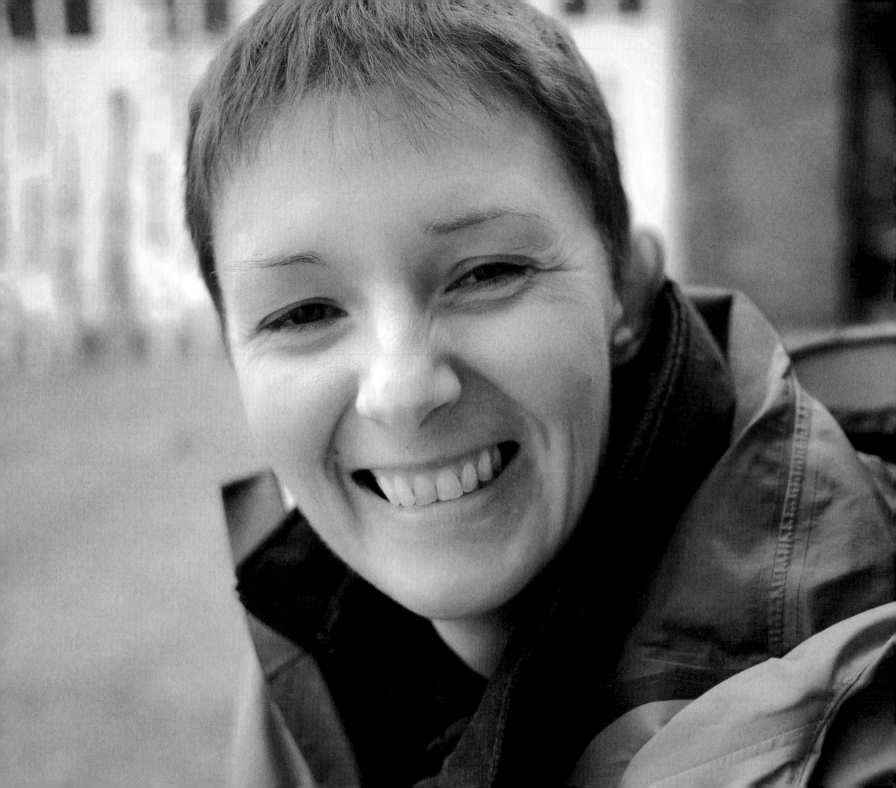

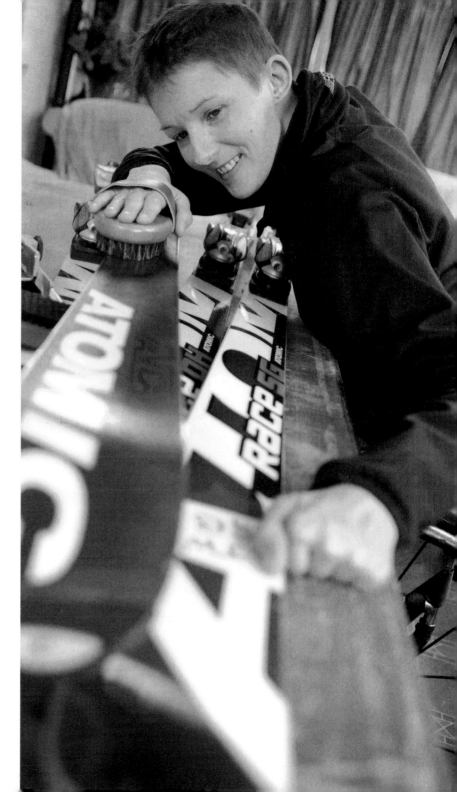

Joe Willoughby

6 APRIL 2012 – JOE'S HOME, STAINCROSS, BARNSLEY, SOUTH YORKSHIRE

Dr Joe Willoughby – born 16 February 1975, Barnsley, South Yorkshire – is a quadriplegic amputee who skis competitively for her country, writes fiction and gives motivational speeches. She is the most successful female sit skier Britain has ever had and has won over thirty medals and titles to date. In 2008 Joe became the European Champion in Giant Slalom.

In 2011, she won the Sports Person of the Year with a Disability at the MBNA Northern Sports Awards. In the same year she won two awards at the Yorkshire Woman of Achievement ceremony – the Jane Tomlinson Woman of Courage Award and the overall Yorkshire Woman of Achievement Award.

Success is a state of mind:
believe it, breathe it, live it
and whatever your results,
you are a success in your own life

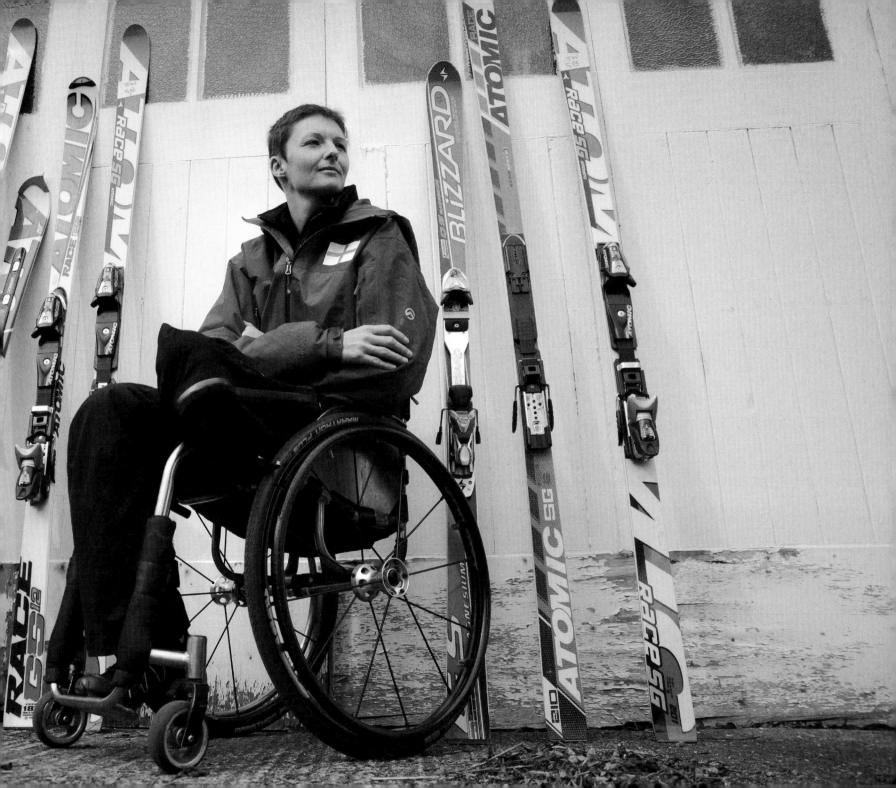

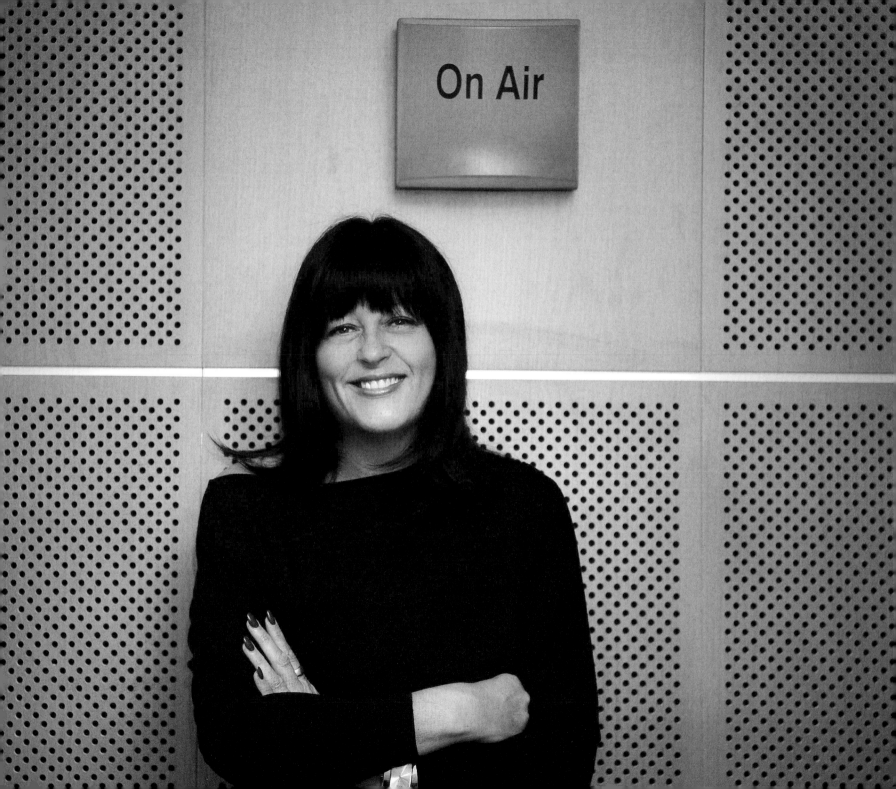

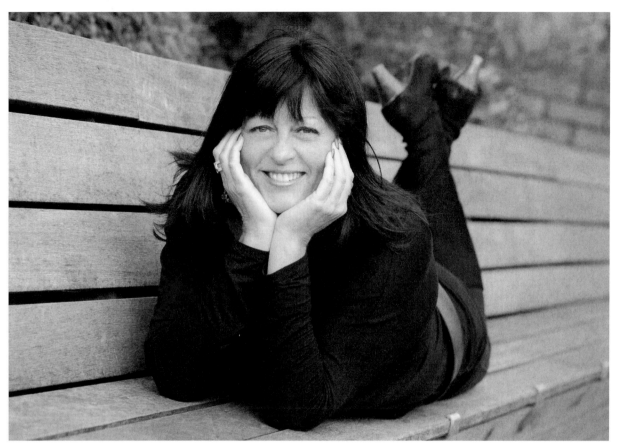

Liz Green

18 JULY 2011 – BBC RADIO LEEDS, LEEDS, WEST YORKSHIRE

My Yorkshire is its heart – hearing our voices and looking at the hills of the Calder Valley and driving over our cobbled streets

Liz Green – born 23 July, 1961, Huddersfield, West Yorkshire – is a Sony Award-winning broadcast journalist who presents *Liz Green Live at Breakfast* on BBC Radio Leeds. Her recent on-air profile has seen Liz interview the Prime Minister, David Cameron, Deputy Prime Minister Nick Clegg and broadcasting legend Sir Michael Parkinson. In November 2011, she was voted Yorkshire Media Personality of the Year.

In June 2013, Liz was awarded Bronze in the prestigious New York Festival Awards, recognising the world's best work in radio broadcasting for her documentary *Death Row*.

She is an ambassador for the Yorkshire Haven Breast Cancer Trust and also for Brain Tumour Research and Support across Yorkshire (BTRS).

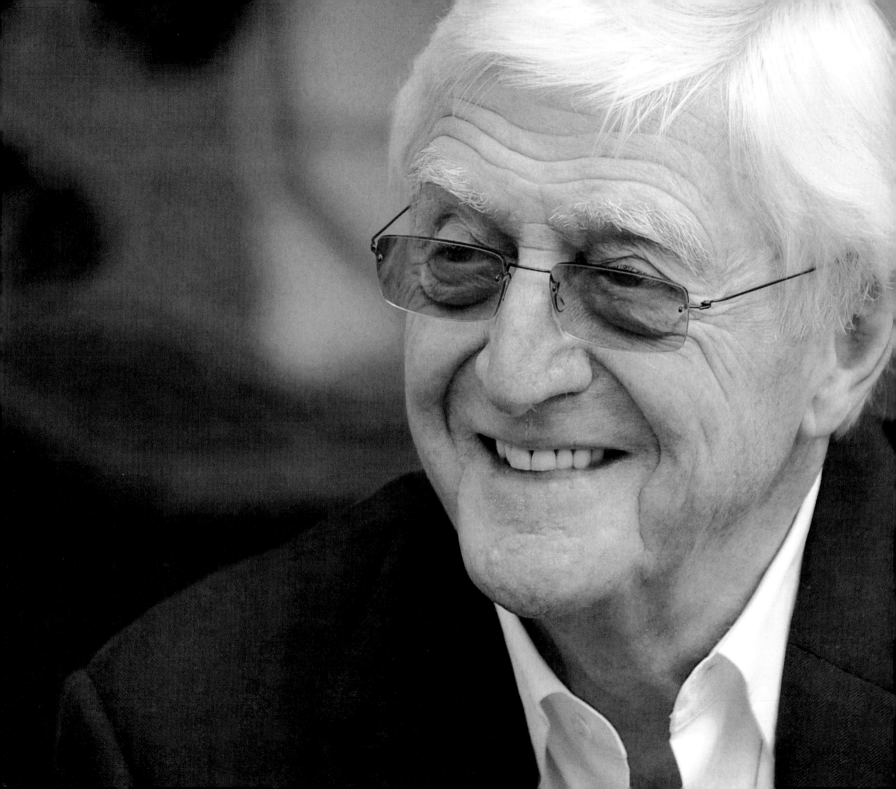

Michael
Parkinson

30 JULY 2011 – ROYAL HALL, HARROGATE, NORTH YORKSHIRE

Sir Michael Parkinson, CBE – born 28 March, 1935, Cudworth, Barnsley, South Yorkshire – is an award-winning broadcaster, journalist and author with a career spanning over sixty years.

He began his career as a newspaper journalist, later moving into television with Granada, where he worked on current affairs programmes and *Cinema* before joining the BBC's *24 Hours* team.

His talk show *Parkinson* ran from 1971 to 1982 and 1998 to 2007. He has interviewed around 2,000 of the most famous people in the world, including Muhammad Ali, George Best, Madonna and Dustin Hoffman, along with Hollywood greats such as John Wayne, Bette Davis, Gene Kelly and Ingrid Bergman.

On radio he presented *Desert Island Discs* (1986–87), *Parkinson on Sport* (1994–96), and then *Parkinson's Sunday Supplement* on Radio 2 in 1996, which ran for twelve years.

He has won numerous awards and in 1998 was separately honoured for his work in journalism, radio and television, a feat thought to be unique. A BAFTA followed in 1999.

Parkinson was voted in the top ten in a British Film Institute poll of the best television programmes of all time.

He was awarded a CBE in 2000 and a knighthood for services to broadcasting in the 2008 New Year Honours List.

Most recently he presented *My Favourite Things* for Radio 2, featuring his kind of music, and in 2012 returned to television with his new series for Sky Arts – *Parkinson: Masterclass*.

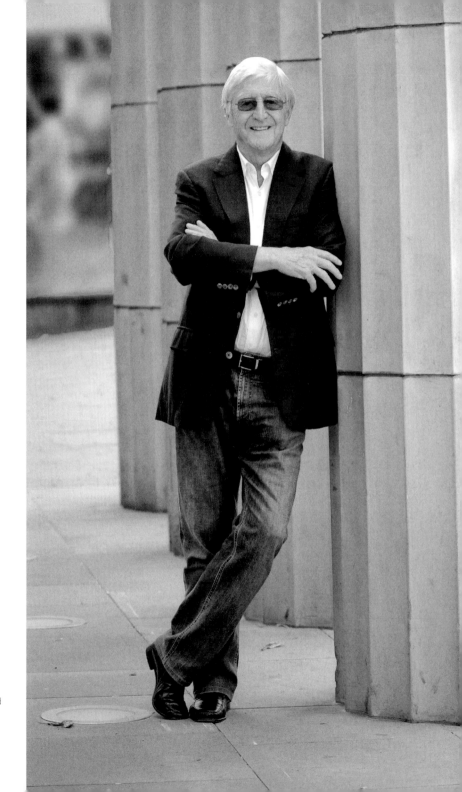

My Yorkshire: an accent, a culture,
a humour, a sense of pride in
being a Yorkshireman

'Ayup, tha' what' – it baffles
everyone, me included!

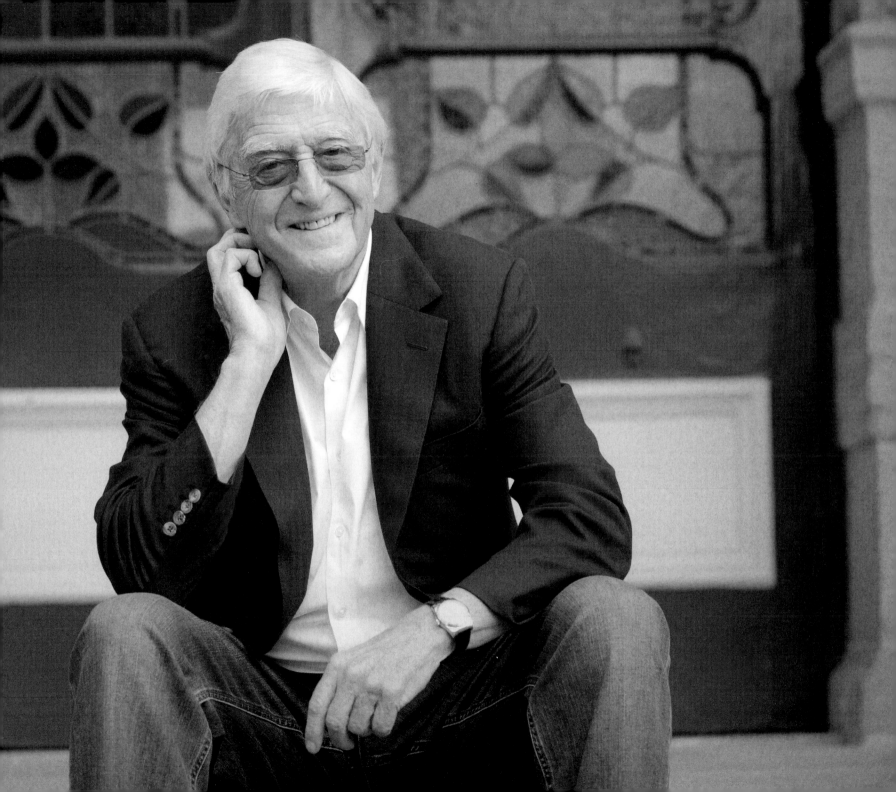

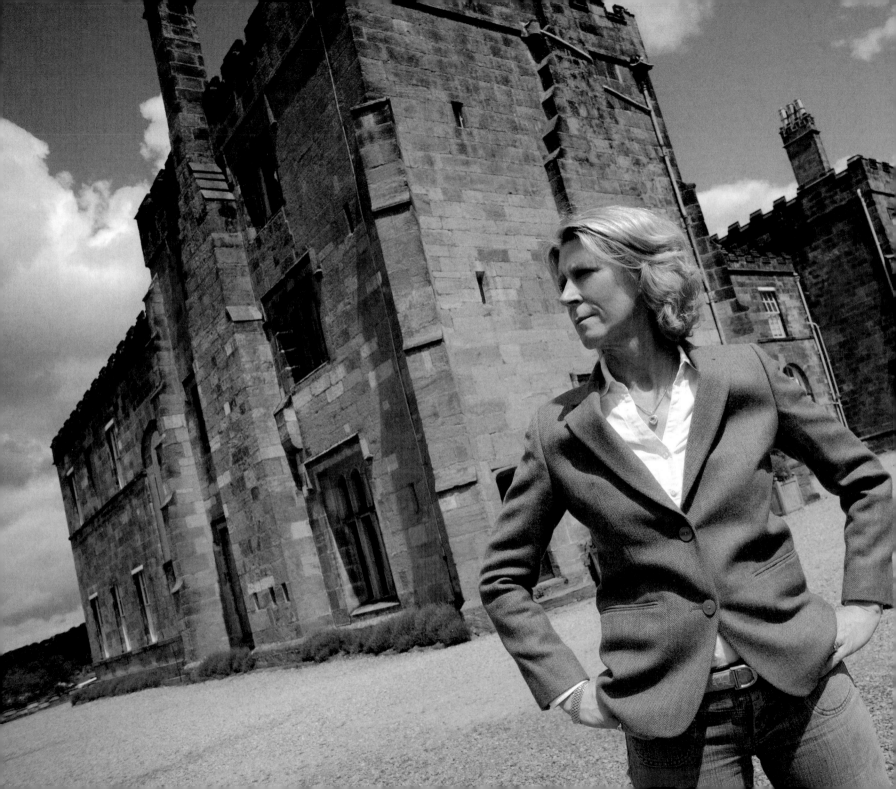

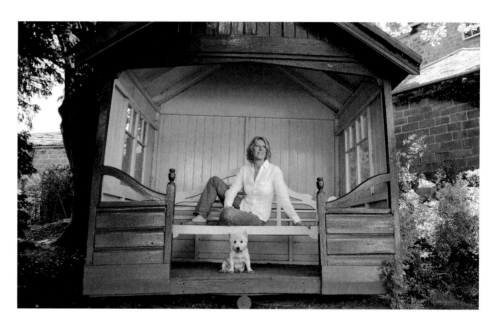

Emma Ingilby

18 JUNE 2012 – EMMA'S HOME, RIPLEY CASTLE, NORTH YORKSHIRE

Lady Emma Ingilby – born 7 May 1960, Whinfield, Strensall, York – is joint owner of the Ripley Castle Estate, Harrogate, and a prolific charity fundraiser. Emma married Sir Thomas Ingilby in 1984, whose family became keepers of the original castle over 700 years ago in 1309. This is the twenty-sixth generation of Ingilbys to live in it, a record only a

handful of stately homes in the country can match. Emma is patron and avid supporter of many charities including the PPR Foundation Brain Tumour Research, Unicef and Candlelighters – the Yorkshire children's cancer charity, the Haven, Leeds, and the Prince's Trust, for which she has helped raise hundreds of thousands of pounds.

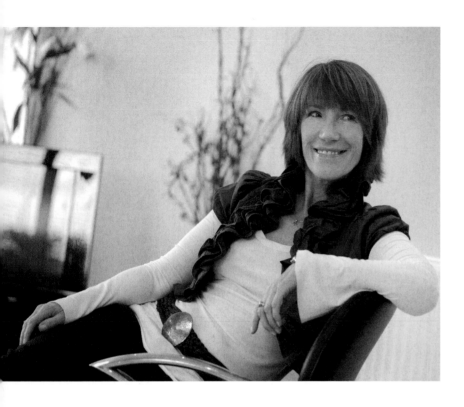

Kiki Dee

25 SEPTEMBER 2011 – KIKI'S SISTER'S HOME AND OVERLEAF AT THE
ALHAMBRA THEATRE, BRADFORD, WEST YORKSHIRE

Kiki Dee (born Pauline Matthews) – born 6 March 1947, Little Horton, Bradford, West Yorkshire – is a singer with a career spanning over fifty years. At the age of twelve, Kiki won a talent competition at the Alhambra Theatre, Bradford – four years later she was signed by Fontana Records and found herself singing backing vocals for the legendary Dusty Springfield. In 1970, Kiki became the first British artist to be signed by Tamla Motown in America. In the 1970s, Kiki became widely known with hits such as *I've Got the Music in Me, Amoureuse* and her number one single with Elton John, *Don't Go Breaking My Heart*.

Kiki appeared in two West End theatre productions in the 1980s including the musical *Blood Brothers* for which she received a Laurence Olivier Award nomination.

She has released thirty-nine singles, three EPs and twelve albums to date and is still touring and performing live.

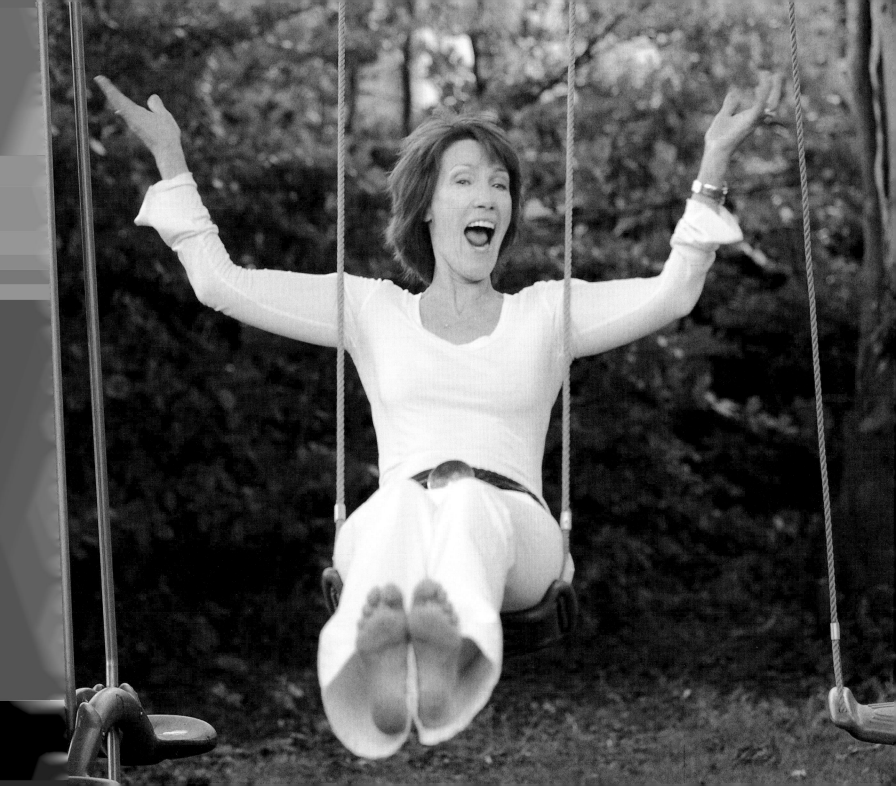

Being from Bradford and having to travel down to London in the sixties to start to try and make it as a singer was hard, but I managed to dip in and out of the 'swinging sixties' madness and keep my feet on the ground by returning home often

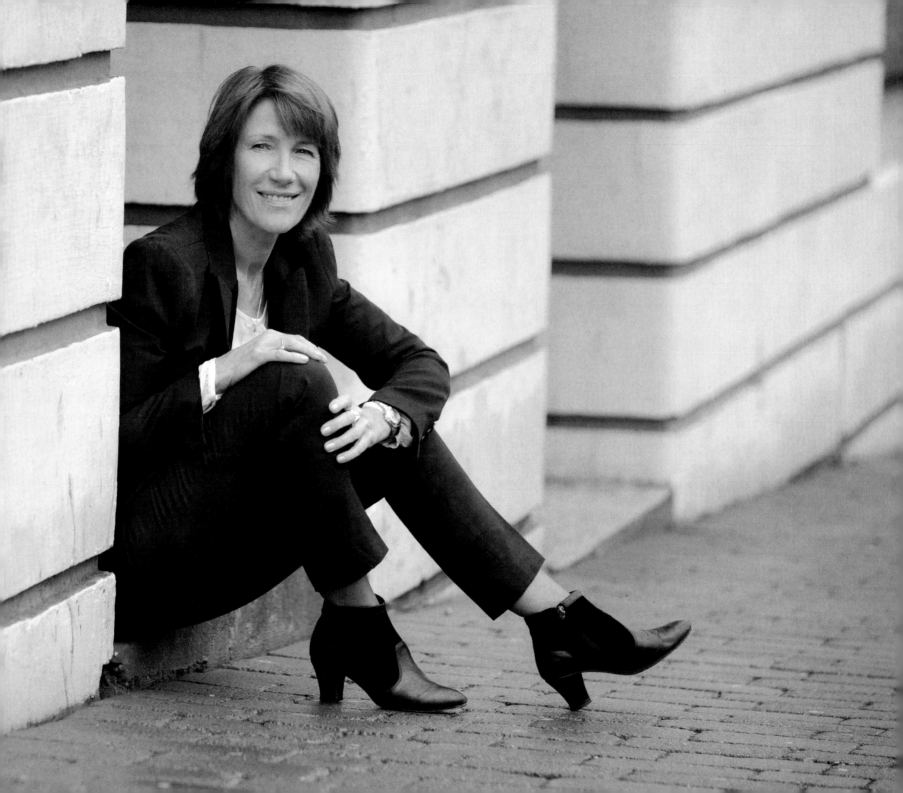

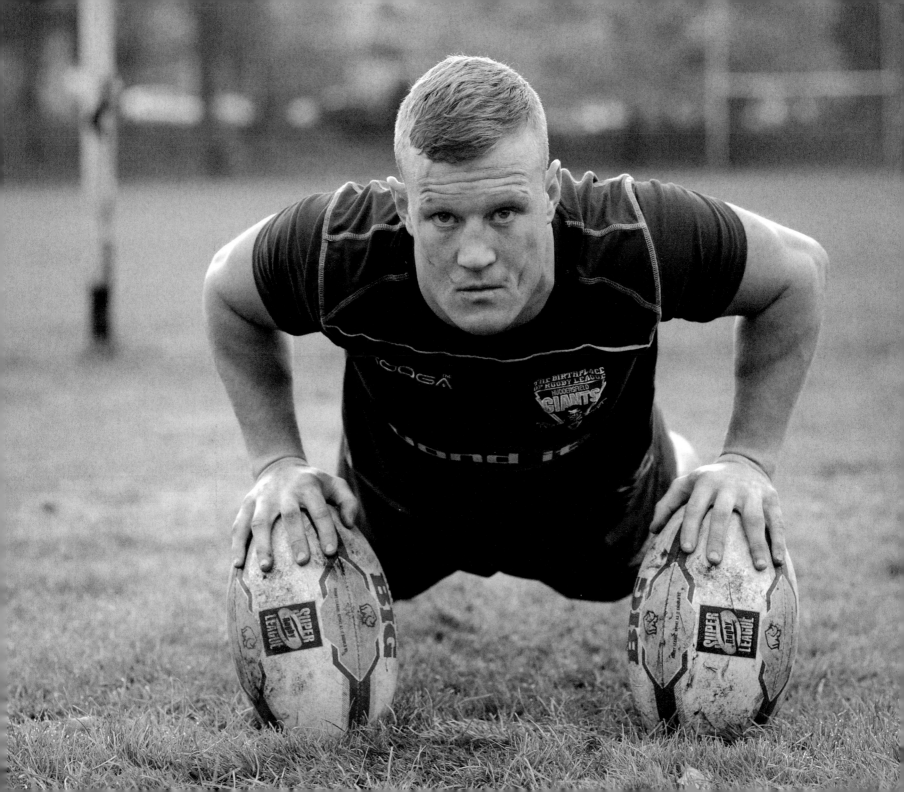

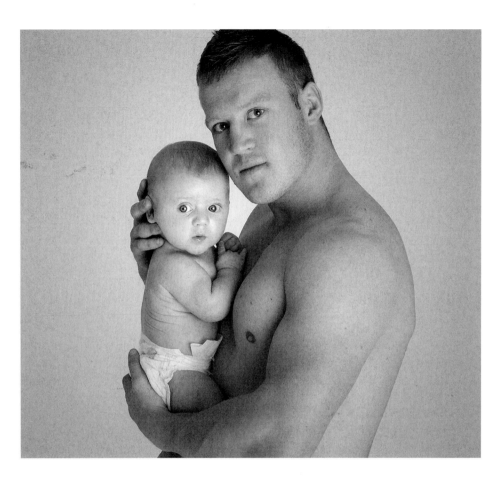

Luke Robinson

ABOVE: 13 JANUARY 2012, LUKE WITH HIS SON LEO, HALIFAX, WEST YORKSHIRE
LEFT & OVERLEAF: 28 NOVEMBER 2013, HUDDERSFIELD GIANTS' TRAINING GROUND, WEST YORKSHIRE

Luke Robinson ('Robbo') – born 25 July 1984 – is a professional rugby league player in the Super League for Huddersfield Giants and has played scrum-half/halfback internationally for England. He has previously played for Wigan Warriors, Castleford Tigers and Salford City Reds. Since leaving Salford City Reds and signing for Huddersfield Giants in 2008, Luke has been one of the team's most consistent and talented performers and picked up the Player's Player and Coaches' Player of the Year awards in 2011.

Luke's greatest accolade in his career to date was being voted England's Man of Tour in the 2010 tour of Australia and New Zealand.

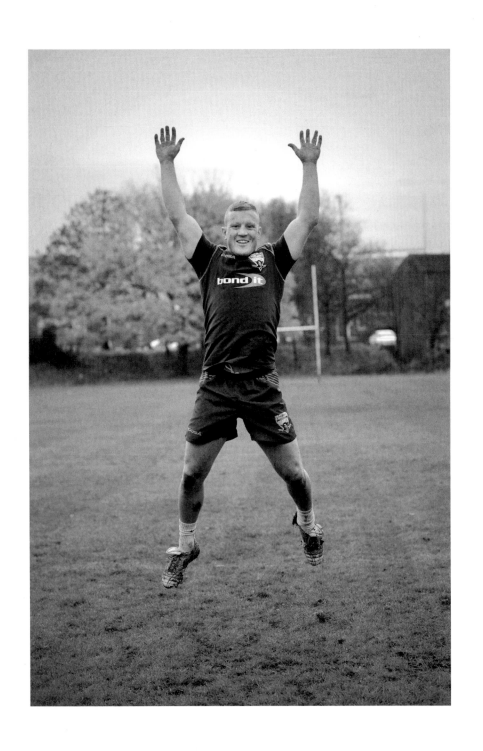

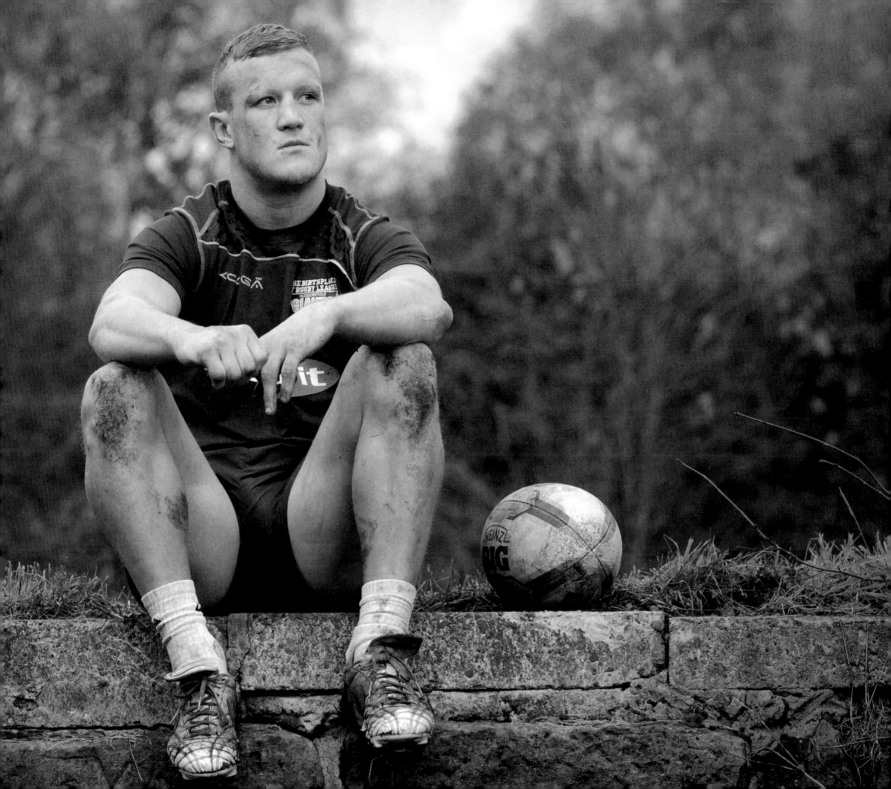

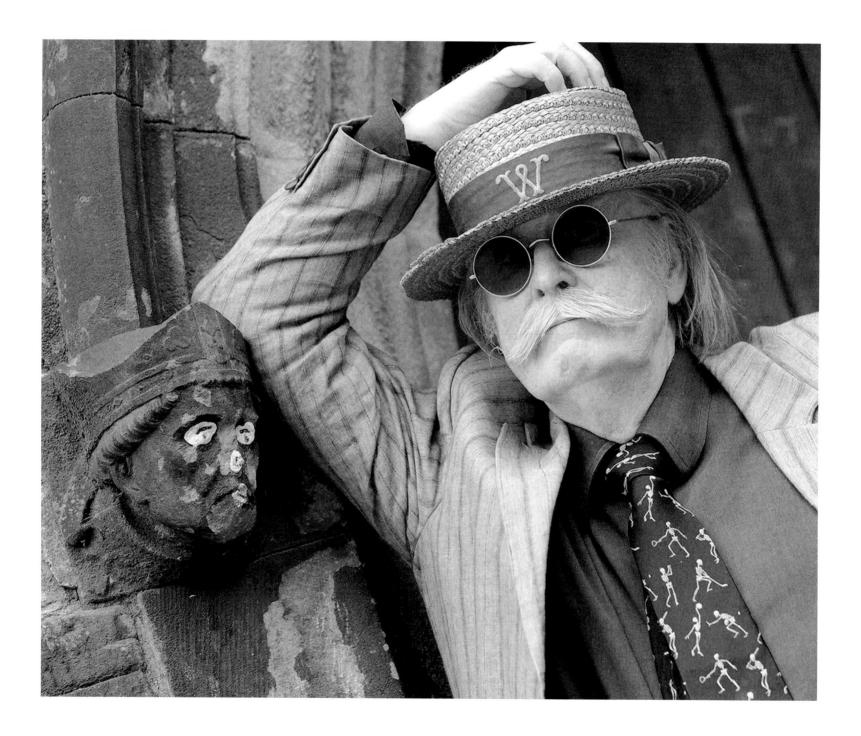

Where's my favourite part of Yorkshire? Well, at my age it's anywhere there's a decent toilet nearby!

Wilf Lunn

14 JULY 2011 – WEST YORKSHIRE PRINT WORKSHOP, MIRFIELD

Wilfred Lunn – born 20 March 1942, Rastrick, West Yorkshire – is an inventor, prop-maker, cartoonist, author and television presenter. He is well known for demonstrating his latest inventions on the 1960s and '70s children's television show *Vision On*, with Tony Hart and Sylvester McCoy, and later in the 1980s in *Jigsaw* and the Classic BBC Television series *Eureka!*

He has written four books, is a prolific constructor of bicycles and regularly exhibits his strange and wondrous devices and wacky inventions.

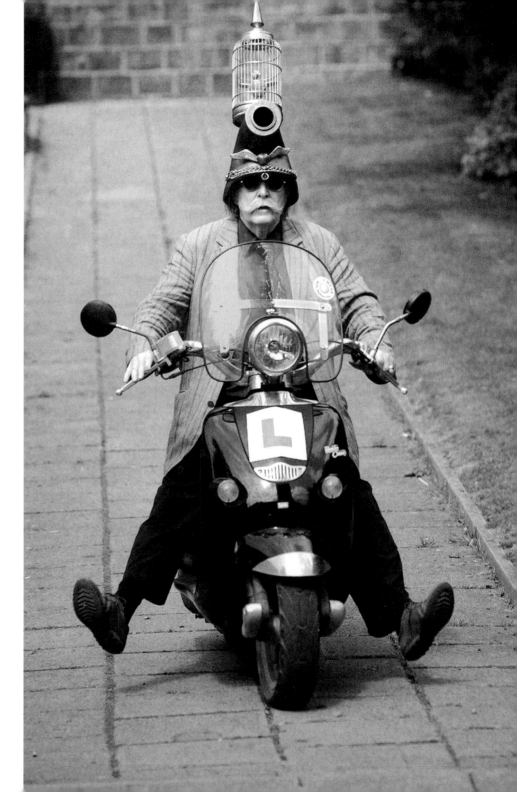

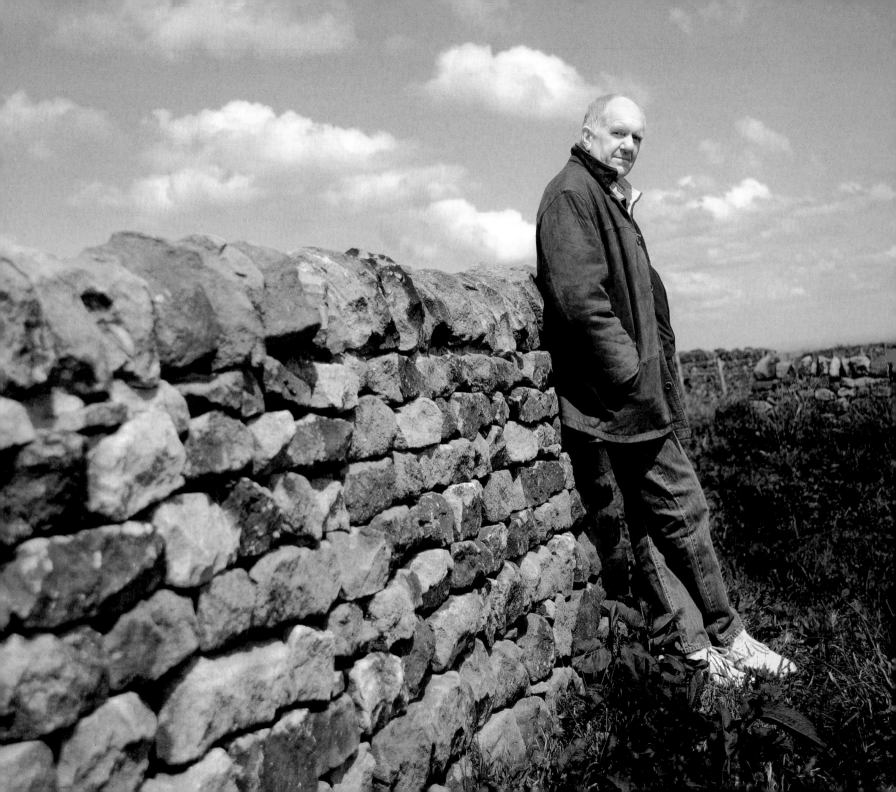

Duncan Preston

9 JUNE 2011 – CHEVIN MOOR, OTLEY, WEST YORKSHIRE.

Duncan Preston – born 11 August 1946, Bradford, West Yorkshire – is an actor with a career spanning over forty years. One of the most recognisable faces on television and stage, he is probably best known for his appearances in *Victoria Wood as Seen on TV*, *Acorn Antiques*, *Dinnerladies* and ITV's soap *Emmerdale*. Also a renowned Shakespearean actor, he has performed in many productions for the Royal Shakespeare Company, including Trevor Nunn's acclaimed version of *Macbeth* alongside Judi Dench and Ian McKellan.

He is a proud Yorkshireman and was awarded an honorary Doctor of Letters degree by the University of Bradford in 2002 for his contributions as an actor.

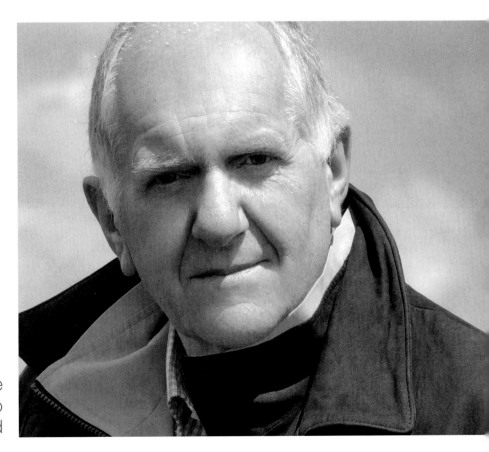

Otley – Chevin – love the place, my father used to bring me here as a child

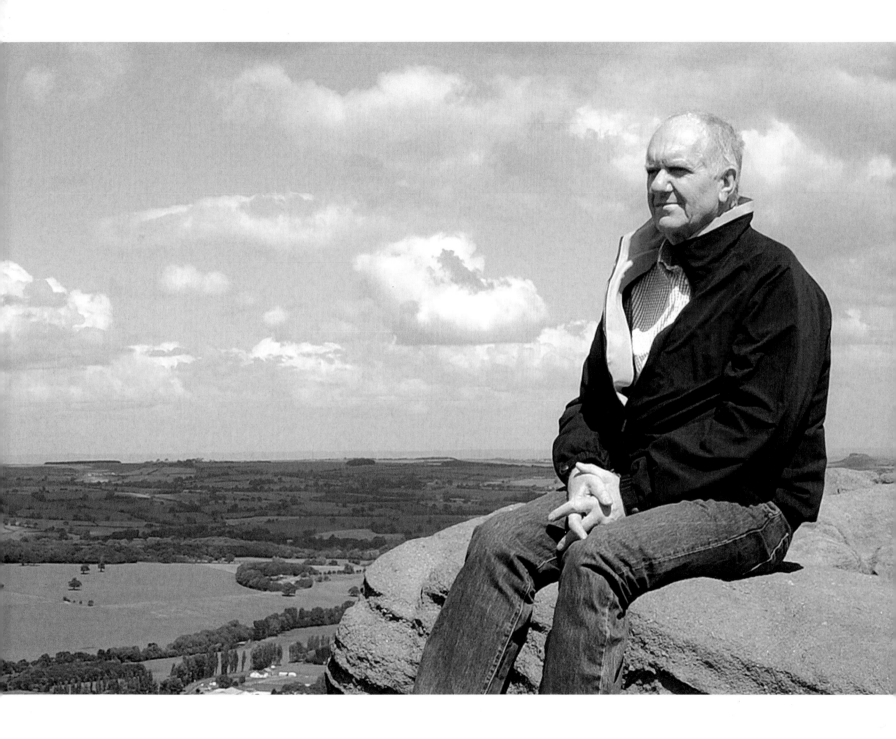

First published in 2014
by Palatine Books,
Carnegie House,
Chatsworth Road
Lancaster LA1 4SL
www.palatinebooks.com

British Library Cataloguing-in-Publication data
A catalogue record for this book is available from the British Library

SOFTBACK ISBN 13: 978-1-874181-94-1
HARDBACK ISBN 13: 978-1-874181-97-2

Designed and typeset by Carnegie Book Production
www.carnegiebookproduction.com

Printed and bound by Jellyfish Solutions

The biographical information was correct at the time of photographing